MANCHESTER BOLTON & BURY CANAL

THROUGH TIME

Paul Hindle

AMBERLEY PUBLISHING

Acknowledgements

Photograph Credits

John Fletcher, Paul Hindle, Manchester Bolton & Bury Canal Society Archives, Heritage Photographic Archive, Webb Aviation.

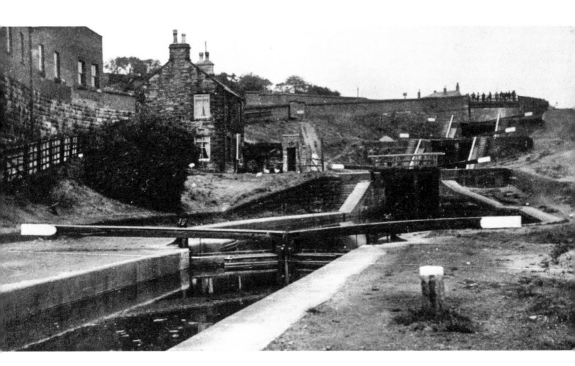

First published 2013

Amberley Publishing
The Hill, Stroud, Gloucestershire, GL5 4EP
www.amberley-books.com

Copyright © Paul Hindle, 2013

The right of Paul Hindle to be identified as the Author of this work has been asserted in accordance with the Copyrights, Designs and Patents Act 1988.

ISBN 978 1 4456 1799 2 (print)
ISBN 978 1 4456 1813 5 (ebook)

British Library Cataloguing in Publication Data.
A catalogue record for this book is available from the British Library.

Typesetting by Amberley Publishing.
Printed in Great Britain.

Introduction

The Manchester Bolton & Bury Canal (MB&BC) received its Act of Parliament in 1791. It was originally conceived as a narrow canal, but during construction there was a scheme to link it to the Leeds & Liverpool Canal at Wigan and it was built as a broad canal. It was opened from Bolton and Bury to Salford by 1797, and connected to the River Irwell in 1808. Its layout was Y-shaped, following the River Irwell from Salford to Bury, and the Croal to Bolton, and the three arms met at Nob End in Little Lever. The summit level ran from Bolton to Bury without locks, and all seventeen locks (raising the canal over 177 feet) were on the Salford arm. The main flight of locks was at Nob End (oddly called Prestolee Locks), which consisted of two sets of three-rise staircases. There were two more staircase locks in Salford, each a two-rise. The total length was 15 miles 1 furlong. Fletcher's Canal (to Wet Earth Colliery) was built in 1791 and was connected to the MB&BC at Clifton by 1800.

Two other canals from Bury to Haslingden and to Sladen (near Rochdale) were planned but not implemented. Had the various proposed branches been built the Leigh Branch of the Bridgewater Canal and the Rochdale Canal from Manchester to Rochdale would probably not have been built, and the Haslingden Canal would have been the highest canal in the country. Instead, the MB&BC remained rather isolated from the rest of the canal system, had finally connected across the River Irwell to the Bridgewater Canal via Hulme Locks in 1838, and to the Rochdale Canal via the largely underground Manchester & Salford Junction Canal in 1839.

The MB&BC was essentially a coal-carrying canal, with numerous collieries. Many collieries built their own tramways to the canal – over the years there were some twenty lines totalling over 6½ miles, extending the reach of the canal as an integrated transport system.

In the 1830s the canal company proposed to turn itself into a railway company, but eventually decided to keep the canal, instead building the Manchester and Bolton Railway, which was opened in 1838. The joint canal and railway company passed to the Lancashire and Yorkshire Railway in 1847, and eventually to the London, Midland and Scottish (LMS) Railway. The canal had a long period of success, and continued to carry coal and other goods into the twentieth century. After 1900, however, the coal mines started to shut down; the last one to close was at Ladyshore in 1949.

The canal was closed in stages; the Bolton branch was disused by 1924, and a major breach at Nob End in 1936 severed the Bury arm, though it continued to see traffic until 1951. Traffic continued between Salford and Clifton until 1950; the whole canal was officially closed by 1961, though a short length carried coal to Elton paper mill in Bury until 1966. The Bolton arm, which closed first, has suffered the most damage; the A666 (St Peter's Way) was built along the line of the canal near the centre of Bolton; and three aqueducts (Farnworth, Fogg's and Damside) were demolished. The Bury arm is still mostly in water, although it is cut in two by the lowered Water Street Bridge in Radcliffe and infilled for the last mile into Bury; the 1936 breach remains at the start of the arm. The Salford arm is still in water from Nob End to Ringley (it supplied Stoneclough paper mill with water until the 1990s), but the rest is largely dry. Prestolee and Clifton Aqueducts still stand, the former still in water, though the small Lumb's Aqueduct has been demolished.

Restoration

The canal society was formed in 1987, and began to clean up the derelict canal. Its members dredged the canal from Ladyshore to Bury, ran a boat from Radcliffe, and helped ensure that two bridges were rebuilt to full navigable standards. It continues to have working parties, and has kept the towpath clear from Ringley to Hall Lane and Radcliffe, including Prestolee Locks at Nob End.

The construction of the Inner Relief Road in Salford in 2001/02 threatened to sever the canal close to its connection, with the River Irwell, but a tunnel was created to preserve the route, named after our former Chairman Margaret Fletcher. British Waterways announced the restoration of the canal in 2002, surveyed the route in 2003, and obtained funding for the first stage in Salford in 2004 with the canal as the focal line of a major redevelopment scheme. Construction work finally began on this Middlewood site in 2007, and the first length was reopened in September 2008.

Another major scheme was the construction of a Meccano bridge over the top lock at Nob End in 2012/13. It was funded by Bolton Council, and designed by the public artist Liam Curtin. The canal society built the bridge and its abutments, acting as principal contractors for Bolton Council.

The next stage of restoration is likely to continue into the Crescent area of Salford. Many development schemes are still on hold in 2013, and this will affect progress. Other parties are looking to fund the restoration of the summit level from Hall Lane (Little Lever) through to Bury. At a time of recession, putting dates on when further restoration schemes might come to fruition has become rather difficult!

Further Reading

Corbett, J., *The River Irwell* (1907)
Cornish, R., *Coal, Canals and Cotton – the Fletcher family in and around Bolton* (MB&BCS 2008)
Dean, R., *Historical Map of the Canals of Manchester* (2001)
Fletcher, J. C., *Moving Milestones* (MB&BCS Magazine 63 2004)
Fletcher, J. & M., *Circular Walks on the Manchester Bolton and Bury Canal* (MB&BCS 1992)
Hadfield, C. & Biddle, G., *The Canals of North West England*, vol 2 (David & Charles 1970)
Hindle, P., *The Canals Bolton and Bury Never Saw: the Red Moss, Haslingden and Sladen Canals* (*MB&BCS Magazine 49* 2000)
Hindle, P., *The Manchester Bolton and Bury Railway* (*MB&BCS Magazine 50* 2000)
Hindle, P., *Milestones on the Manchester Bolton & Bury Canal* (*MB&BCS Magazine 59* 2003)
Hindle, P., *The Tramroads of the MB&BC* (*MB&BCS Magazine 62* 2004)
Hindle, P., *Below the Canal* (*MB&BCS Magazine 63* 2004)
Hindle, P., *Towpath Guide 2* (MB&BCS 2013)
'Little Lever Canal Burst Its Banks' *Bolton Journal* (1936) and *MB&BCS Magazine 68* (2005)
Tomlinson, V. I., *The Manchester Bolton and Bury Canal* (MB&BCS 1991)
Waterson, A., *On the Manchester Bolton and Bury Canal* (Neil Richardson 1985)
The Middlewood Restoration: MB&BCS Magazines 69–83 (2005–09)
The Meccano Bridge: MB&BCS Magazines 92–98 (2011–13)
The Holdsworth Diaries: MB&BCS Magazines 88–92 (2010–11)

www.mbbcs.org.uk
www.mangeogsoc.org.uk/egm/3_3.pdf
The society publishes a quarterly magazine (free to members), which has reached 100 editions.

Manchester Bolton & Bury Canal

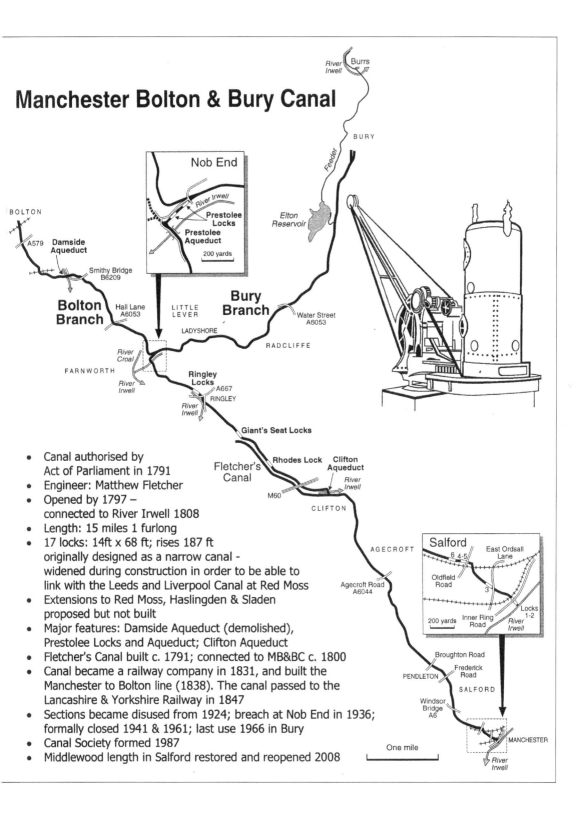

Nob End

River Irwell

Prestolee Locks

Prestolee Aqueduct

200 yards

BURS

River Irwell

BURY

Feeder

Elton Reservoir

BOLTON

A579

Damside Aqueduct

Smithy Bridge B6209

Bolton Branch

Hall Lane A6053

LITTLE LEVER

Bury Branch

Water Street A6053

LADYSHORE

RADCLIFFE

River Croal

FARNWORTH

River Irwell

Ringley Locks

A667

RINGLEY

River Irwell

Giant's Seat Locks

Rhodes Lock Clifton Aqueduct

Fletcher's Canal

M60

River Irwell

CLIFTON

AGECROFT

Agecroft Road A6044

Salford

East Ordsall Lane

6 4-5

Oldfield Road

3

200 yards

Inner Ring Road

Locks 1-2

River Irwell

Broughton Road

PENDLETON

Frederick Road

SALFORD

Windsor Bridge A6

MANCHESTER

One mile

River Irwell

- Canal authorised by Act of Parliament in 1791
- Engineer: Matthew Fletcher
- Opened by 1797 – connected to River Irwell 1808
- Length: 15 miles 1 furlong
- 17 locks: 14ft x 68 ft; rises 187 ft originally designed as a narrow canal - widened during construction in order to be able to link with the Leeds and Liverpool Canal at Red Moss
- Extensions to Red Moss, Haslingden & Sladen proposed but not built
- Major features: Damside Aqueduct (demolished), Prestolee Locks and Aqueduct; Clifton Aqueduct
- Fletcher's Canal built c. 1791; connected to MB&BC c. 1800
- Canal became a railway company in 1831, and built the Manchester to Bolton line (1838). The canal passed to the Lancashire & Yorkshire Railway in 1847
- Sections became disused from 1924; breach at Nob End in 1936; formally closed 1941 & 1961; last use 1966 in Bury
- Canal Society formed 1987
- Middlewood length in Salford restored and reopened 2008

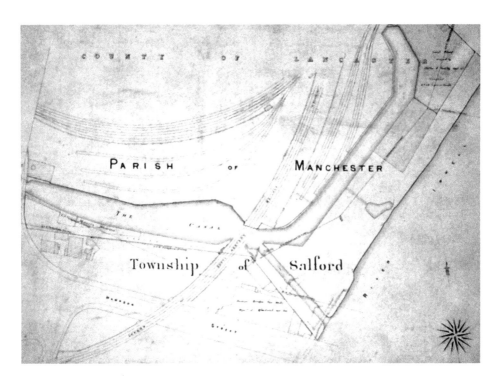

Canal Company Maps, 1881/82

These large-scale maps show the canal in great detail. The upper map shows the canal leaving the River Irwell, straight into the first two locks (a staircase pair); it is joined by the curving Stanley Street Wharf before going under the Manchester to Liverpool Railway line. The lower map shows the canal in greater detail at Lock 3 close to Ordsall Lane, with the lock house and clay yard alongside.

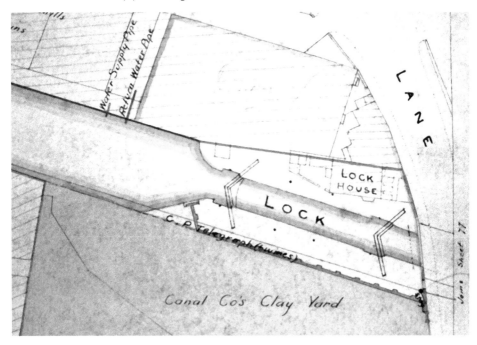

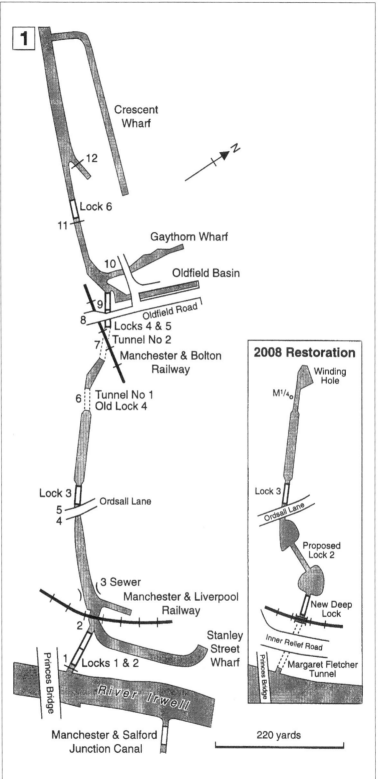

The Start of the Canal in Salford

The main map shows the canal as rebuilt in the 1890s. Locks 4 and 5 had been moved twice to accommodate the Manchester to Bolton Railway. Originally, the canal went in a straight line from old Lock 4 to Lock 6. Numbers 1–12 are mainly bridges. The inset map shows how the canal was altered during the restoration in 2008. Locks 1 and 2 were replaced by a tunnel leading to a new single deep lock. Two new basins lead to Lock 3 where the original line of the canal was rejoined.

Map labels (main map):

1

Crescent Wharf

12

Lock 6

11

Gaythorn Wharf

10

Oldfield Basin

9

Oldfield Road

8

Locks 4 & 5

7 / Tunnel No 2

Manchester & Bolton Railway

6 / Tunnel No 1
Old Lock 4

Lock 3

5
4

Ordsall Lane

3 Sewer

Manchester & Liverpool Railway

2

Stanley Street Wharf

Princes Bridge

1 Locks 1 & 2

River Irwell

Manchester & Salford Junction Canal

Inset map:

2008 Restoration

Winding Hole

M 1/4

Lock 3

Ordsall Lane

Proposed Lock 2

New Deep Lock

Inner Relief Road

Princes Bridge

Margaret Fletcher Tunnel

220 yards

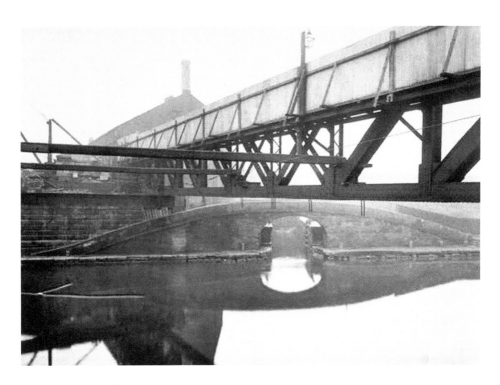

The Entrance to the Canal

Both views are taken from Princes Bridge. The upper picture was taken in 1905 when Princes Bridge was being rebuilt. It shows the river towpath crossing the canal entrance over the curved 'Bloody Bridge'; the lower lock gates of Lock 1 are open. The lower photograph, after restoration, shows the entrance to the Margaret Fletcher Tunnel under the Inner Relief Road, leading to the new deep lock.

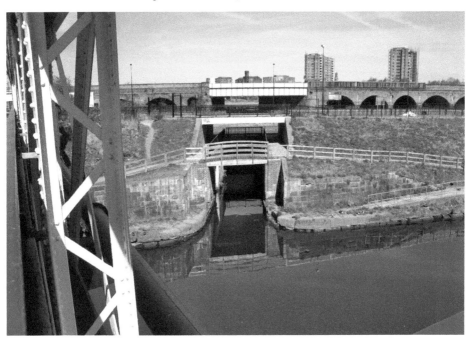

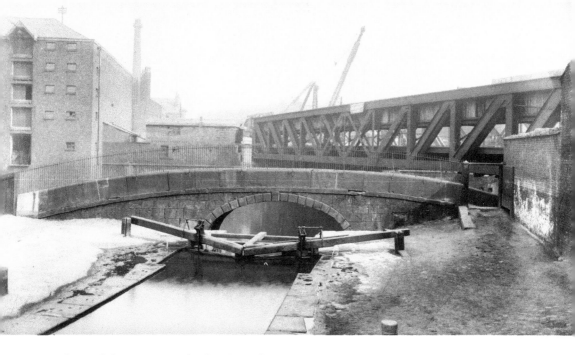

Lock 1 and the Margaret Fletcher Tunnel

The upper picture, taken in 1905, shows a full Lock 1 with Bloody Bridge and Princes Bridge beyond. The lower picture is essentially the same view, but after the 2008 restoration. Locks 1 and 2 have been converted into a tunnel under the Inner Relief Road.

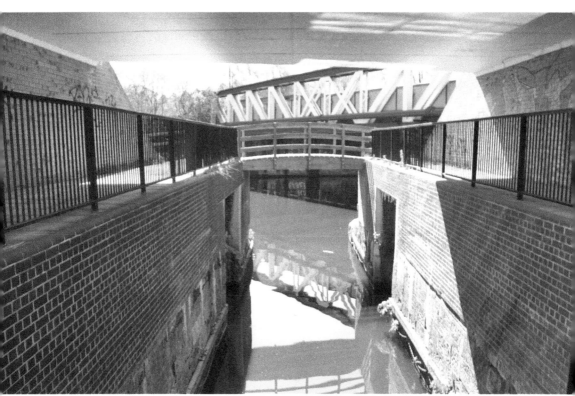

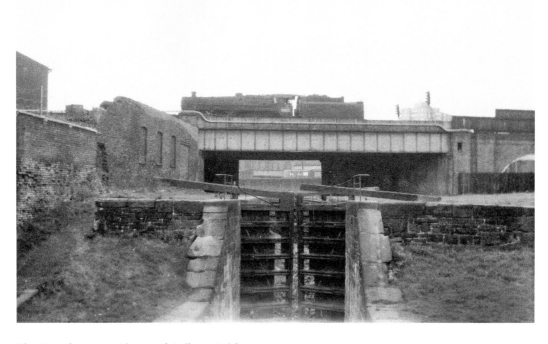

The Manchester to Liverpool Railway Bridge

The upper picture, taken in 1966, shows the middle gates between Locks 1 and 2 in a disused state. The lower picture shows that Lock 2 has been removed, and the canal is now in the tunnel under the new Inner Relief Road.

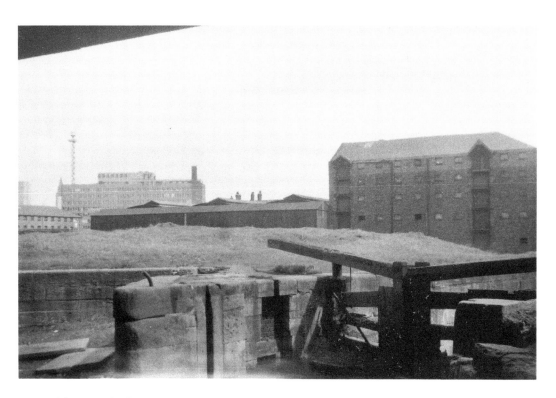

Old & New Locks

The upper picture, taken in 1954, shows the top gates of Lock 2 from under the railway bridge. The gates are clearly derelict. The lower picture shows the new deep lock beyond the railway bridge, which raises the canal 17 feet 8 inches from the river. The Beetham Tower is visible beyond the bridge.

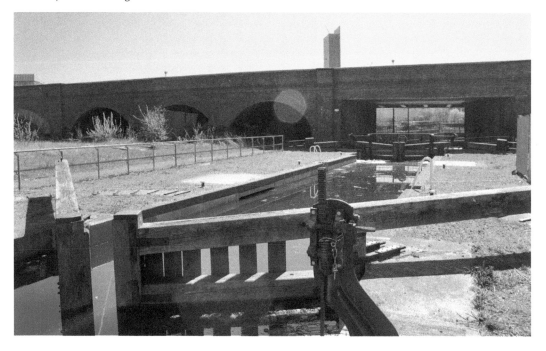

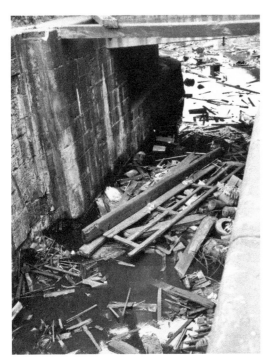
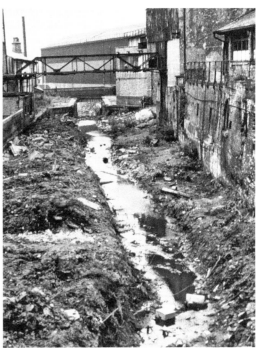

Lock 3

Four views of Lock 3. The upper pictures show the derelict lock in 1954. The lower pictures show the restored lock, one with two narrowboats about to ascend the lock in 2009.

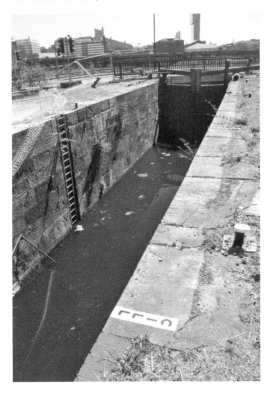
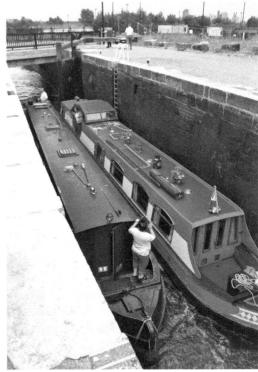

Lock 3 to Tunnel No. 1

The upper picture shows the derelict canal leading to Tunnel No. 1, surrounded by old industrial premises. The lower picture shows the restored canal. The tunnel has gone, though the canal narrows at this point, which was originally Lock 4. The new side walls of the canal have been built inside the line of the old walls due to industrial pollution. The canal here is supplied with water back pumped from the River Irwell, as the canal no longer has its own water supply.

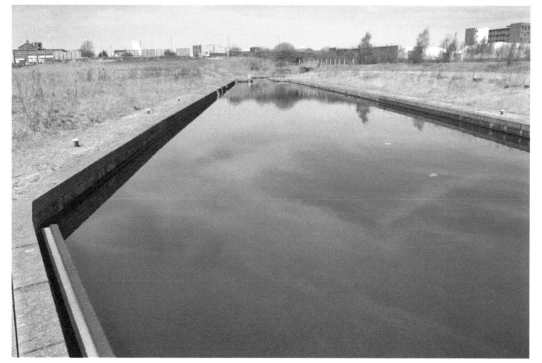

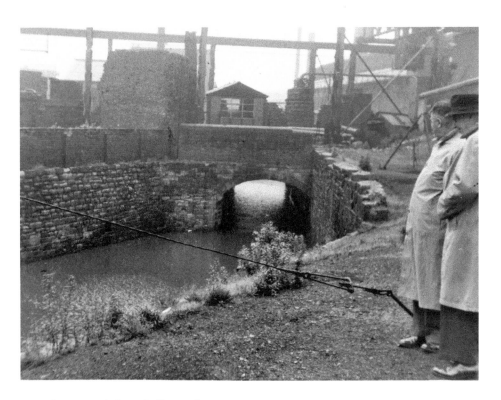

Tunnel No. 1 and the Winding Hole

The upper picture, again taken in 1954, shows Tunnel No. 1 and the industrial premises. The lower photograph is essentially the same view today; the people on the bank in both pictures are in almost the same position. The restored canal ends at the new 'winding hole' that enables full-length boats to turn around. Just beyond is the narrow stretch, which was originally Lock 4, and later Tunnel No. 1. Again, the Beetham Tower looms over the scene.

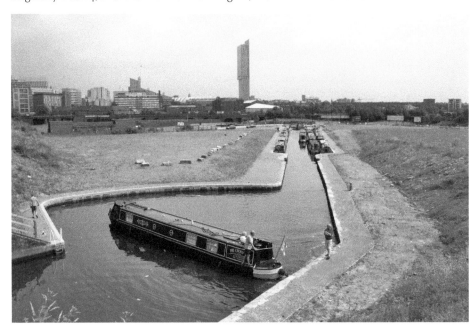

Behind Salford Crescent

The upper picture, a favourite of mine, shows the same two men also seen on the previous page. Here they are walking along the canal above Lock 6. Note the man looking over the wall – presumably trainspotting! Today this length of the canal is virtually inaccessible, but the best way to see the wall is to travel by train from Salford Central to Salford Crescent.

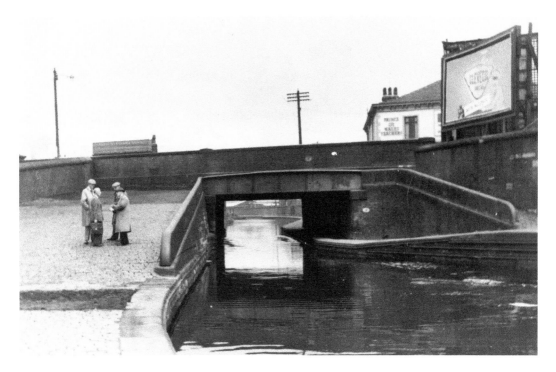

Windsor Bridge

Here the towpath crossed the canal by means of a roving bridge; this enabled horses pulling a boat to change sides without being unhitched. The lower picture shows the present bridge, taken from the other side, which now carries Salford Crescent (A6). In 2013, a new Salford Crescent station was built over the line of the canal, leaving room for the canal to be restored underneath.

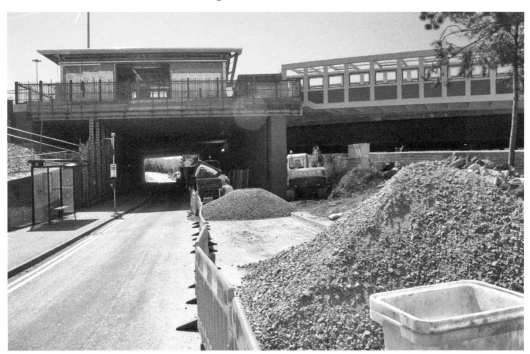

Near Windsor Bridge

The following pages are virtually impossible to replicate today as the canal has been totally obliterated. The upper picture was taken from Windsor Bridge, probably in the 1920s. Salford University now occupies the area to the right. The lower picture shows the same length of canal with Windsor Bridge in the distance. The timber in the canal was floated up from the river, and stored in the water by adjacent timber yards.

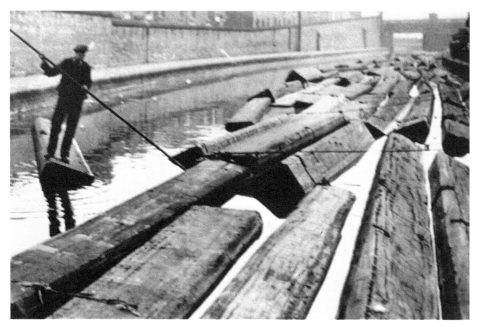

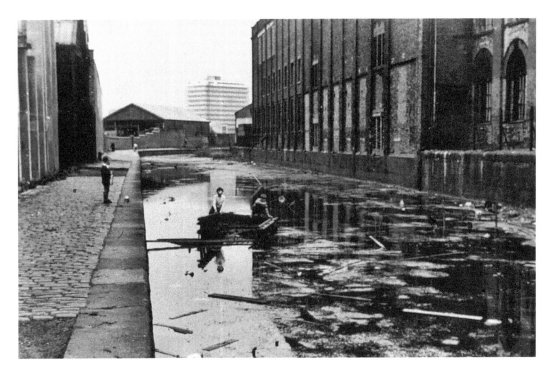

Pendleton

Taken in 1966, the upper picture shows the former power station near Frederick Road, with another timber yard in the middle distance, and the Tower Block of Salford University beyond. The canal is now infilled and the area is occupied by a builders' merchant. The lower picture shows the canal and railway alongside each other at Pendleton station. Broughton Road Bridge, in the background, has now been replaced by an embankment.

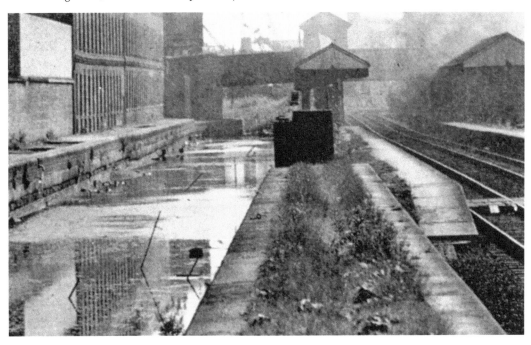

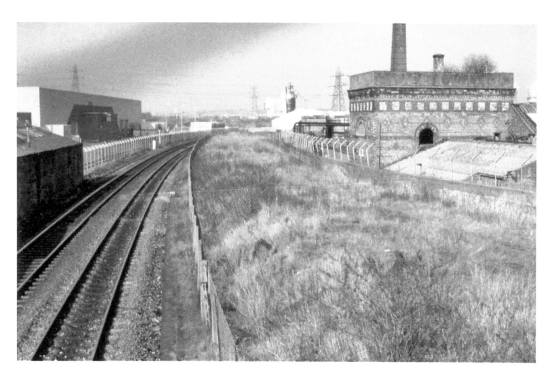

Cock Robin Bridge

Two views from Cock Robin Bridge, taken around 1990 and 2013. The water tower on the right has only recently been removed, but the line of the canal is now heavily overgrown. The canal and railway run alongside each other for over 2 miles – the canal company became a railway and canal company, and built the Manchester and Bolton Railway, which was opened in 1838.

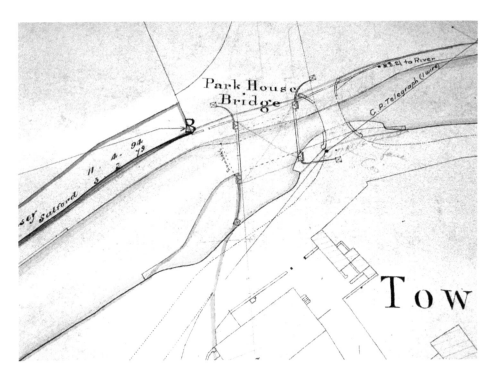

Park House Bridge

The canal company map of 1881/82 shows the original bridge and, to the left, the new wider bridge built in 1886/87. The canal subsided a great deal here in the late nineteenth century due to the workings of Pendleton Colliery underneath. The picture shows the view north from the bridge today (now an embankment). Much work has been done to maintain this first accessible length of towpath, and from here the towpath can be followed almost all the way to Bolton and Bury.

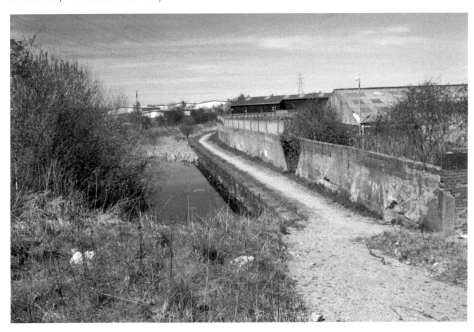

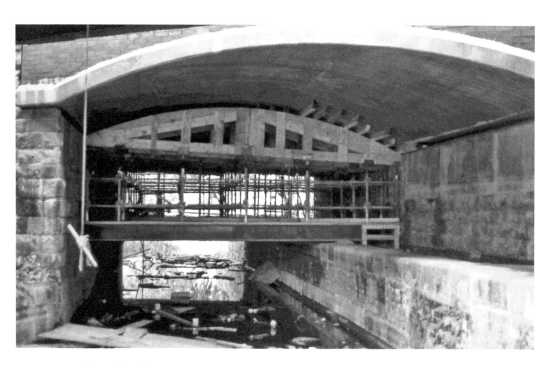

Agecroft Road Bridge

This bridge was rebuilt in 1990 to full navigable height by Salford Council. The lower picture also shows the recently repaired pipes of the Thirlmere aqueduct, originally dating 1892–1909. The canal society has recently restored milestone 3, which can be seen against the right-hand wall.

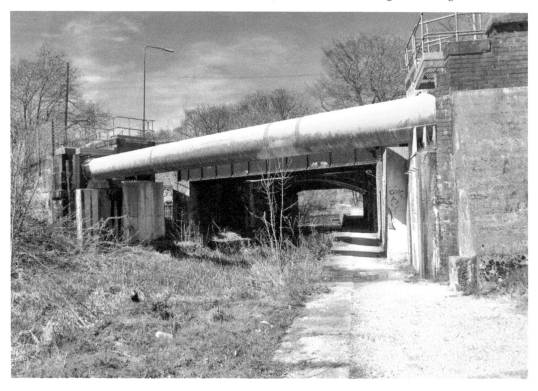

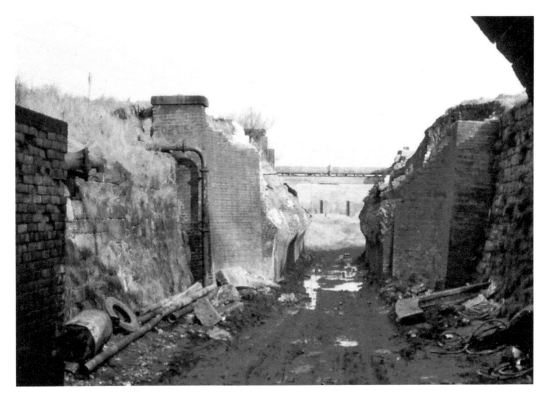

Lumbs Aqueduct

Photographed in around 1970 and in 2013, this small single-arched aqueduct carried the canal over a road; it can also be seen on the map on page 23. It was originally 67 feet long, but was demolished in around 1970, just before the upper picture was taken.

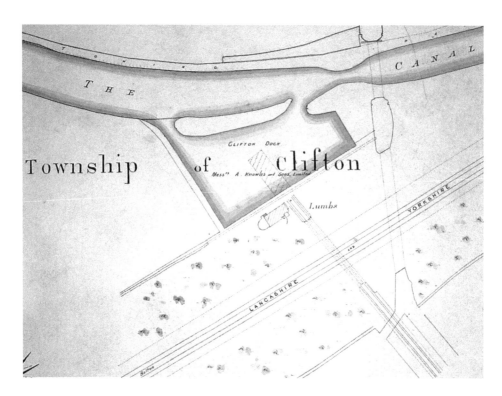

Clifton Dock

The 1881/82 map shows the dock clearly. It belonged to colliery owners A. Knowles & Sons, and had a tramway leading to Clifton Hall and Pendlebury Collieries. When the railway was built in the 1830s, the tramway went in a tunnel underneath – as did the road leading to Lumbs Aqueduct, which is still in use. The dock is still visible, at least in winter, when the vegetation dies down.

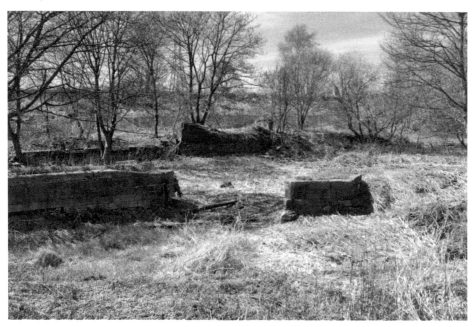

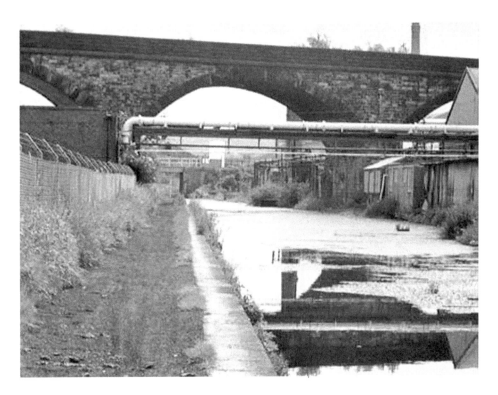

Clifton

The canal passes under one of the 'Thirteen Arches' of the former East Lancashire Railway, and a short length is in water. The land on either side was formerly owned by a battery firm, which installed unsightly fences on both sides of the towpath. Strangely, this short length of towpath is not a public right of way.

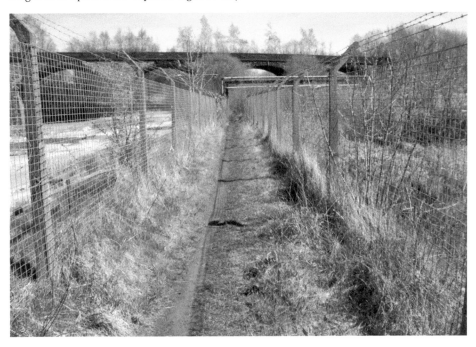

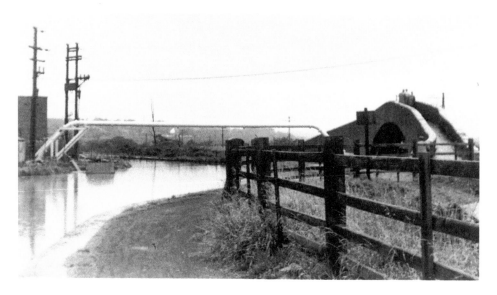

Clifton Aqueduct

The upper picture shows the junction with Fletcher's Canal (straight ahead). The MB&BC turns right under the Pack Saddle Horse Bridge, straight onto Clifton Aqueduct. The lower photograph shows an arrangement of stop plank grooves unique to this canal. Stop planks could be put into either of the grooves on the opposite side, and the canal was drained in either direction by letting water out of the central paddle.

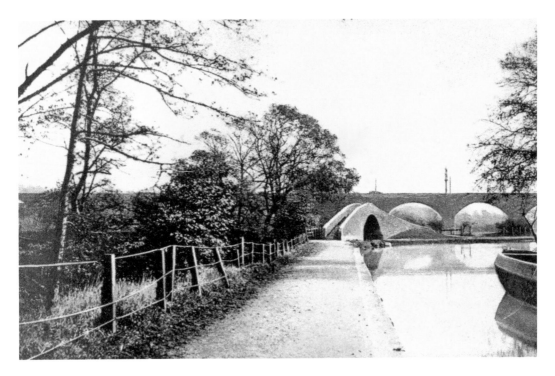

Fletcher's Canal and the Thirteen Arches

Fletcher's Canal is on the right, leading to its junction with the MB&BC and the towpath bridge. The Thirteen Arches took the East Lancashire Railway from Clifton Junction to Radcliffe and Bury, and then on to Ramsbottom, branching to Accrington and Bacup. The first length of the railway is now a nature trail; Metrolink trams use it from Radcliffe to Bury, and steam trains still run from Bury to Rawtenstall.

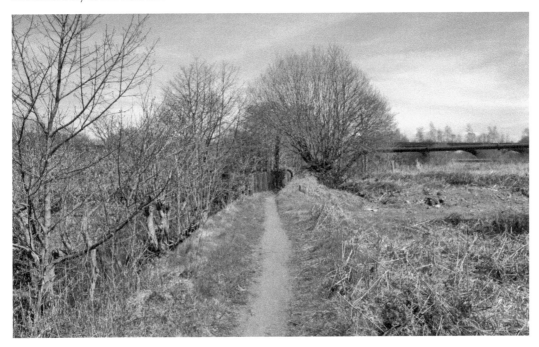

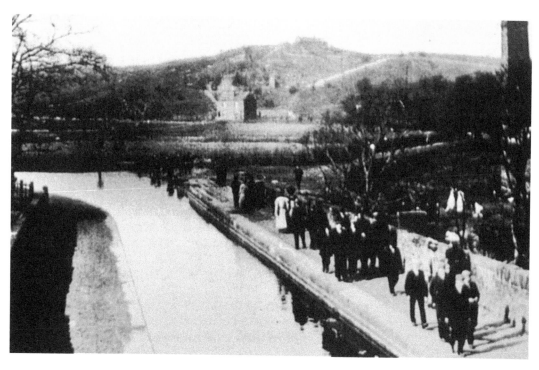

Clifton Aqueduct

The aqueduct was a popular place for Sunday walks, as seen in this 1908 photograph. Beyond the wharf, the canal takes a sharp left to follow the east bank of the River Irwell. Although the aqueduct is still intact, it has been dry for many years.

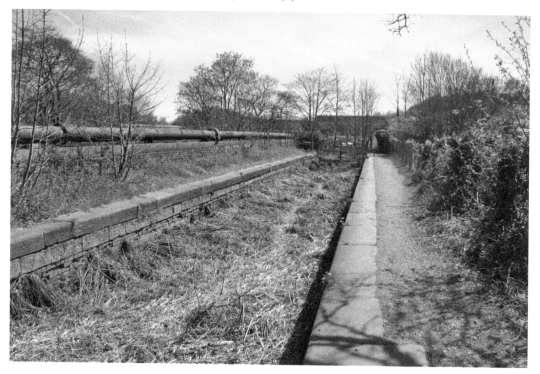

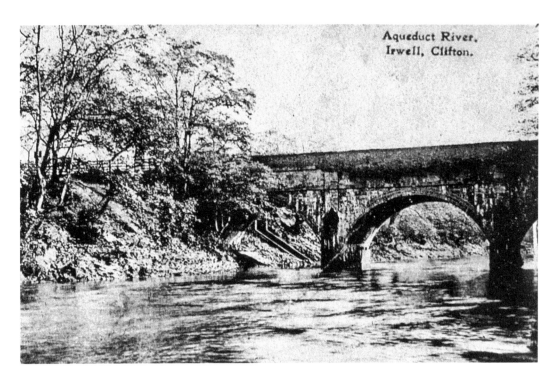

Aqueduct River.
Irwell, Clifton.

Clifton Aqueduct

The aqueduct is described in the bridge list: 'Stone abutments, piers, spandrels and cut waters, brick arches and parapet walls. Brick and stone face walls to waterway. Length 153 ft. Waterway face walls rebuilt 1902 and 1907. Fence walls rebuilt 1908 and 1910. Public footpath over east side. Towing path over west side.'

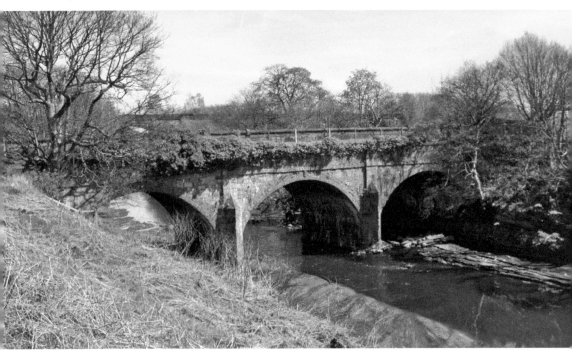

Clifton Aqueduct and the M60

After crossing the river, the canal continues along the right-hand side of the river seen in the upper picture. In the distance, the M60 bridge crossing the river is visible; the motorway severed the canal by a massive embankment, but it may be possible to reroute the canal under the bridge. The lower photograph shows the motorway bridge from the other side; the fencing on the left is on the line of the coping stones, and the path was the towpath.

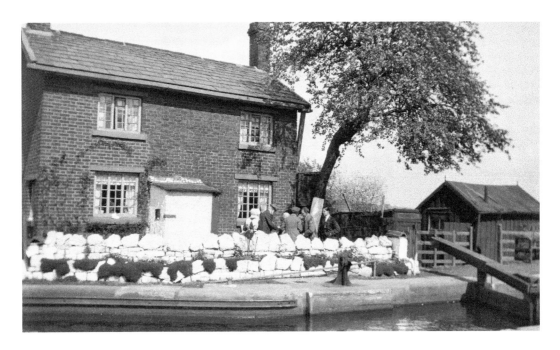

Rhodes Lock

Rhodes Lock was in an isolated place, but the lock-keeper's house is seen, probably in the 1920s, in immaculate condition with whitewashed stones. Everyone in the photograph is wearing their 'Sunday best'. Today the lock is heavily overgrown, but it is thought to be intact. The lower picture was taken in 2013, looking up the lock chamber; the house (demolished in 1933) was formerly on the right-hand side.

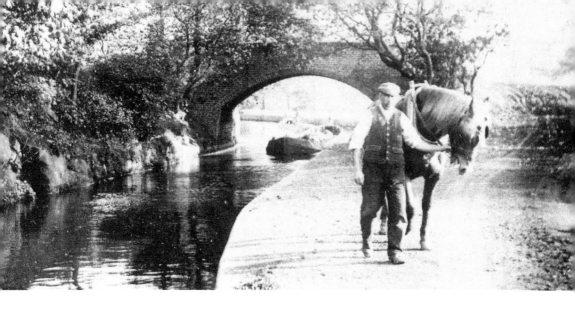

Kilcoby Bridge

The upper picture shows a horse-drawn narrowboat under the bridge. Today, the canal is totally infilled, and a private road leads off left to the former Bolton Sewage Works and Kilcoby (New Outwood) Brickworks. The canal towpath comes in from the right. Old Margaret Barlow's tea rooms used to be nearby, now replaced by a garden centre.

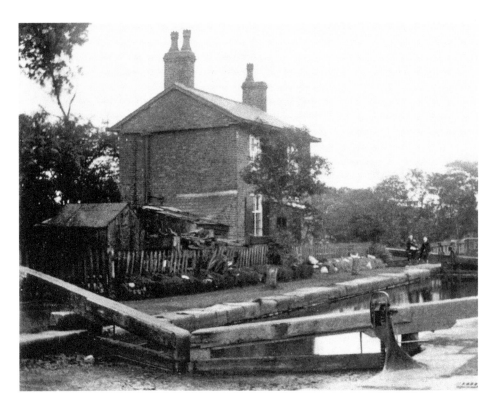

Giant's Seat Lock House

There were two locks at Giant's Seat; the pictures show the lock house, which still stands by the upper lock. Both locks are infilled, though traces of the upper lock are just visible in the grass. The lock house is the only one surviving on the canal, built in the mid-nineteenth century, though it has been extended. The path to the right of the wire fence is still a public right of way, though access at either end is often difficult.

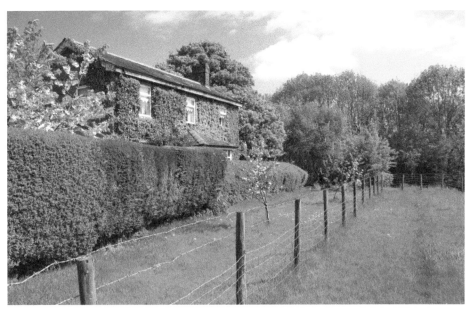

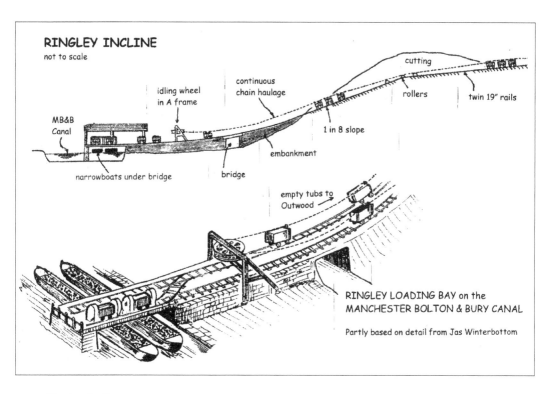

RINGLEY INCLINE
not to scale

cutting

idling wheel
in A frame

continuous
chain haulage

rollers

twin 19" rails

MB&B
Canal

1 in 8 slope

embankment

narrowboats under bridge

bridge

empty tubs to
Outwood

RINGLEY LOADING BAY on the
MANCHESTER BOLTON & BURY CANAL

Partly based on detail from Jas Winterbottom

Ringley Incline

A mile-long tram road led from Clough Side (later Outwood) Colliery to the canal. It had a cutting and embankment to give a slope of up to 1 in 8. It may have been in use from 1830, and was converted to steam-driven continuous chain operation in 1870–74, eventually closing around 1910. The colliery itself closed in 1931. The impressive cutting and embankment in Ringley Woods survive as a little-known piece of industrial archaeology.

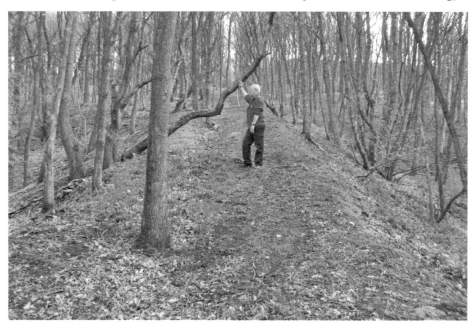

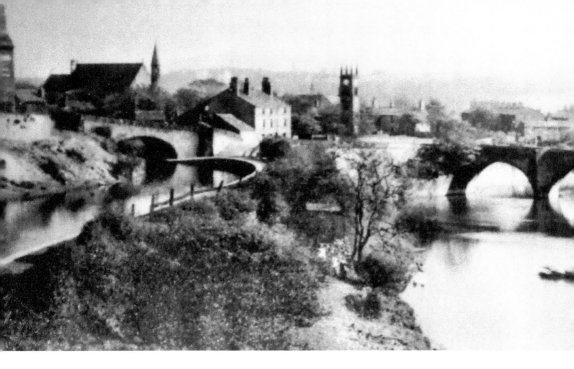

Ringley

Ringley has changed a good deal since the upper picture was taken in around 1920. The canal is now infilled, the bridge demolished, and the Horseshoe pub rebuilt. The old church tower (built in 1625) and the packhorse bridge, however, still survive. In the lower picture, the canal bridge formerly stood in the centre; the white front of the pub and the bottom of the old church tower can just be seen to the right. Behind the pub, milestone 6¾ was reinstated by the canal society in 2011.

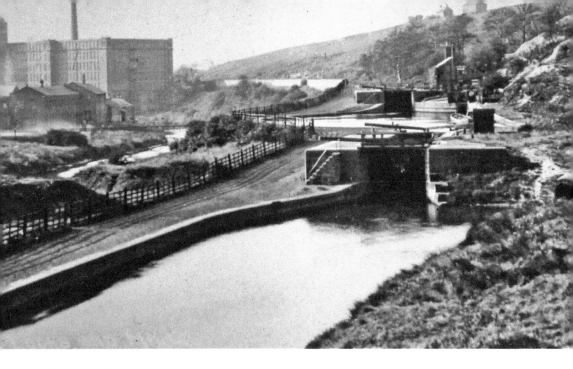

Ringley Locks

Another pair of locks followed at Ringley; once again, the canal is alongside and well above the River Irwell. The upper picture shows both locks, the lock-keeper's house, and, in the distance, Irwell Bank Mills, built alongside the canal in 1894 and demolished in 1977. The lower lock has been almost completely removed, but much of the upper lock remains. Milestone 7 still stands near the upper lock. Below is a painting of the upper lock and the lock house.

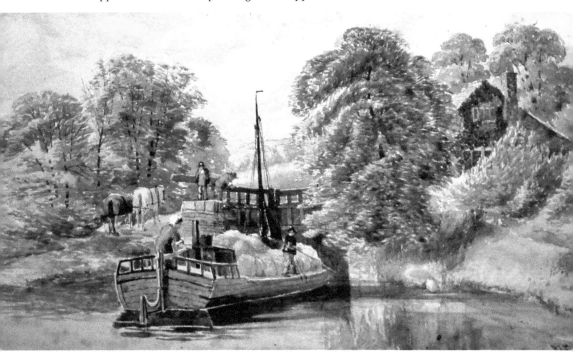

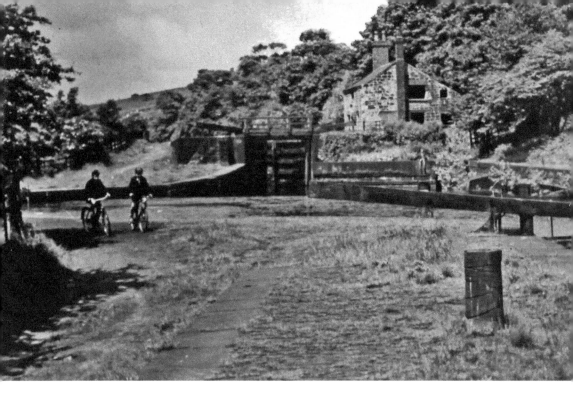

Ringley Locks

The upper picture is a particular favourite, showing the derelict lock house and two boys on their bikes wearing caps. The photograph was probably taken in the early 1950s before the lock house was demolished. The lower picture is another painting of the top lock and lock house.

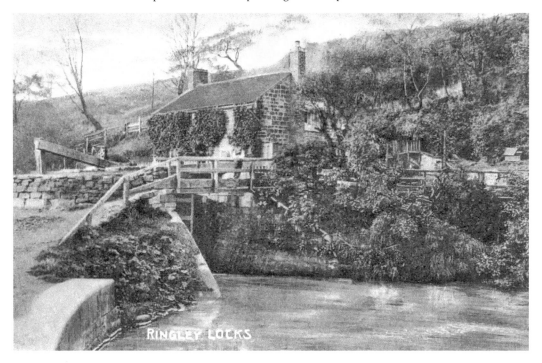

RINGLEY LOCKS

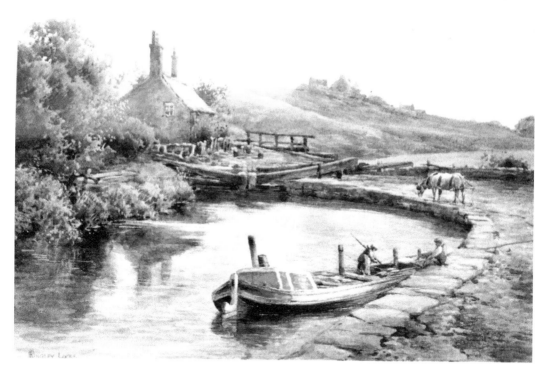

Ringley Locks

The upper picture is yet another painting of the top lock and lock houses; this was clearly a favourite spot for painters. The lower photograph shows a similar view today; the canal (now in water) runs right up to the lock, but trees obscure the view and the lock house is long gone.

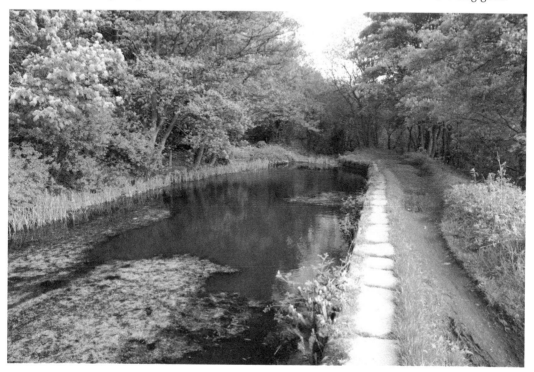

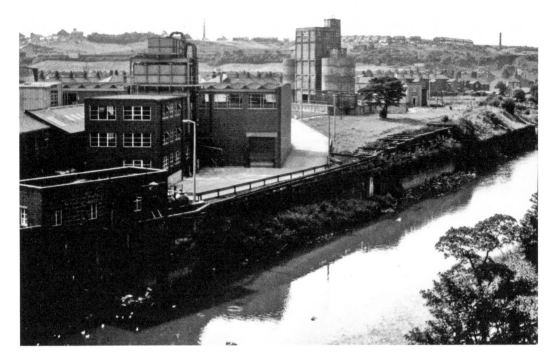

Stoneclough

The village of Stoneclough stands on the opposite bank of the River Irwell. Fletcher's paper mill, seen in the upper picture, was founded in 1823, and was recently demolished. It obtained half of its water supply from the canal, which meant that it had high-quality water – most of which came out of the Irwell at Burrs (above Bury). The canalside control valve (*see below*) is all that survives; the mill site is now a small housing estate.

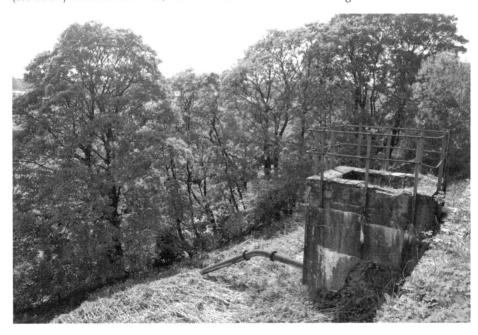

Appleyard Bridge

The old wooden bridge was replaced by Bolton Council by a new concrete and brick bridge in 1998; the canal society lobbied to have it rebuilt to full navigable standards, rather than the road being dropped and the canal culverted. It carries the unadopted Prestolee Road across the canal. Note the thin sandstone slabs forming the boundary wall.

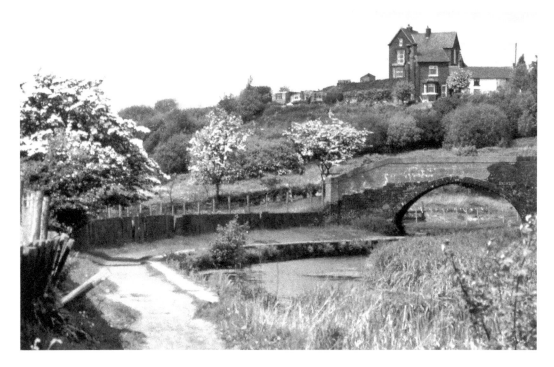

Prestolee Aqueduct

The upper picture, taken around 1990, shows the approach to the aqueduct and the first view of Nob End. Prestolee (or Silver Hill) Bridge was used as a location in the James Mason film *Spring and Port Wine* (1970). The aqueduct is a most impressive structure; it has four arches over the river, is about 70 yards in length and carries the canal some 40 feet above the River Irwell. Now over 200 years old, it is still in water and needs little maintenance.

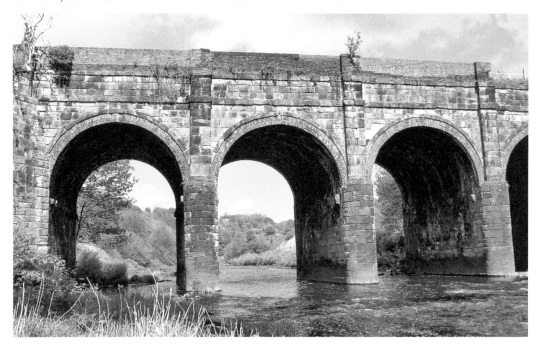

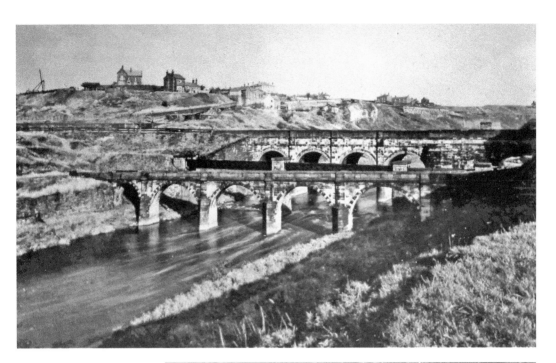

Prestolee Aqueduct
The upper picture shows the aqueduct, and, in front of it, a packhorse bridge and a sewer bridge built in 1899. The latter was replaced by a concrete bridge in the 1960s, and it remains an eyesore between the two historic structures. The aqueduct actually has a fifth arch on the south side, in and around which are numerous mason's marks normally hidden inside the structure.

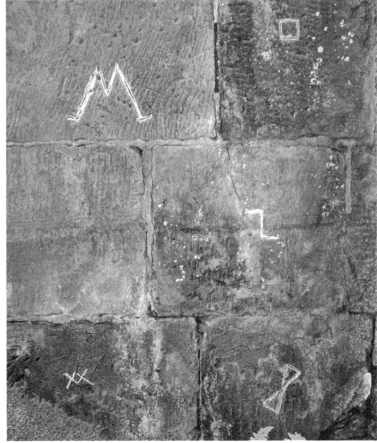

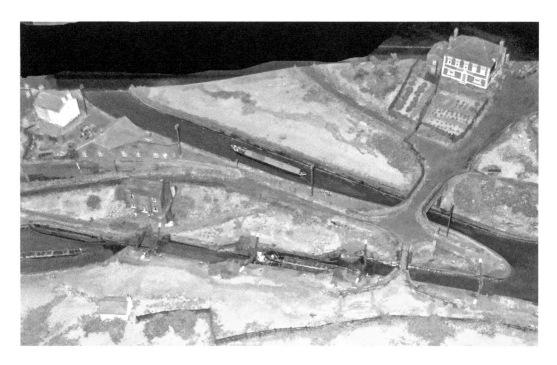

Prestolee Locks

The six locks were arranged in two staircases of three locks, with a short pond in the middle. This model of the locks is in Bolton Museum, and shows the whole area around the locks when they were fully operational. The upper picture shows the cottages, workshops, lock-keeper's house, the top three locks and the Nob Inn. The lower picture is looking up the locks with a boat entering the lowest lock.

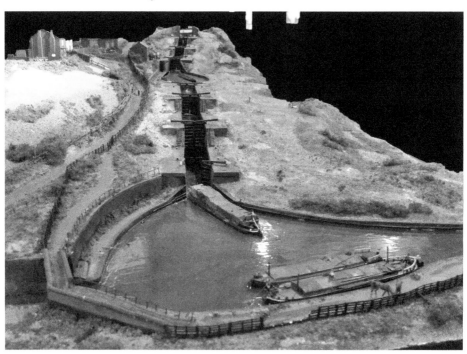

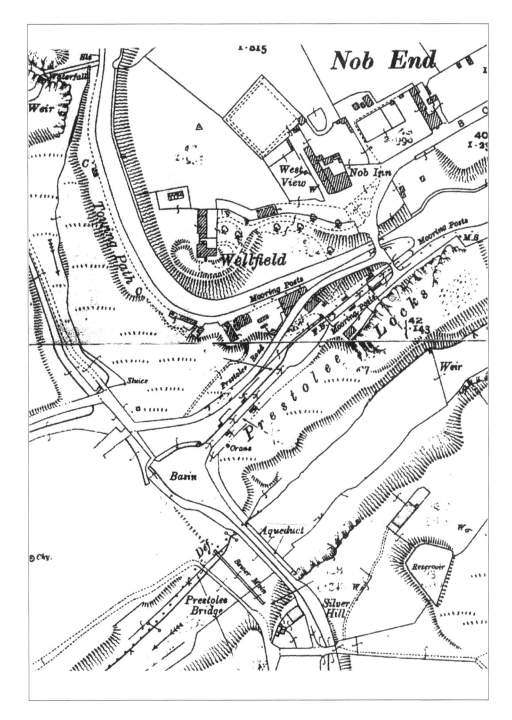

Nob End on the Ordnance Survey 25-inch Map

The map shows the canal from Silver Hill Bridge to the aqueduct, turning basin (two short private arms led off from here), Prestolee Locks, and then the junction, turning sharply to the left for Bolton or straight ahead for Bury. There is argument about whether these locks should be called Nob End Locks, as they are not actually in Prestolee, but all the maps call them Prestolee Locks.

43

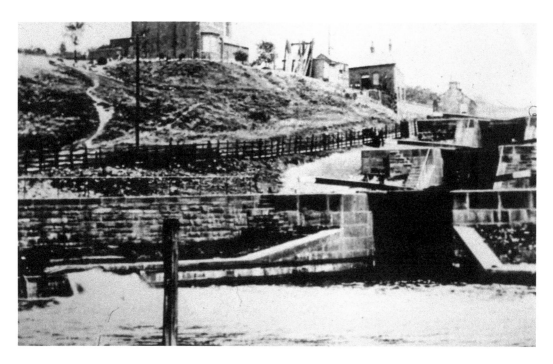

Prestolee Locks

Two views of the canal basin and the lower locks; the stonework has been partly dismantled. Two branch canals lead off to the left serving a quarry, tramway and vitriol works. Overall the 6 locks raise the canal 64 feet in just 200 yards to the summit level.

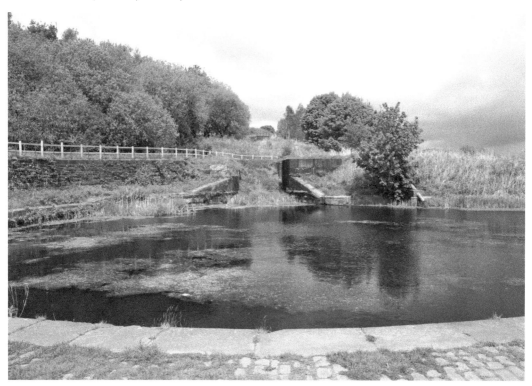

44

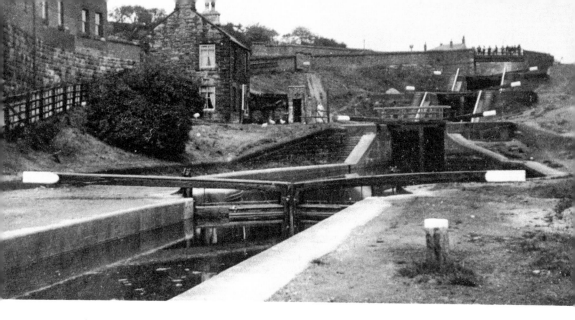

Prestolee Locks

Above is perhaps the most commonly used image of the canal. It was taken from the top of the lower staircase, looking across the middle pound to the upper staircase. Also visible are the workshops, the lock house and a crowd on the wooden bridge across the top lock. Today only the stonework of the locks remains, though the bridge has been replaced (*see pages 90–96*).

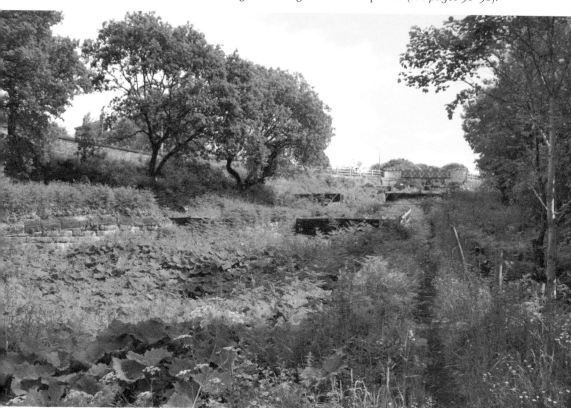

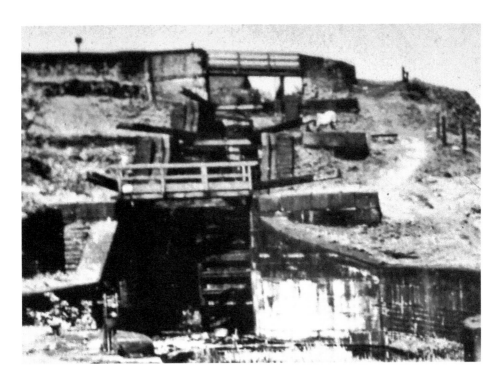

Prestolee Locks

The upper picture shows the upper staircase and Bridges 49 and 50. Both were unnamed, though 50 (across the top lock) was referred to as a 'horse bridge', allowing horses to get from the Bolton to the Bury arm. The lower picture was taken in the 1970s. Today the heavily overgrown locks tend to disappear in the summer, although the canal society does try to keep the vegetation down! Note that Bridge 50 looks rather different now (*see pages 90–96*).

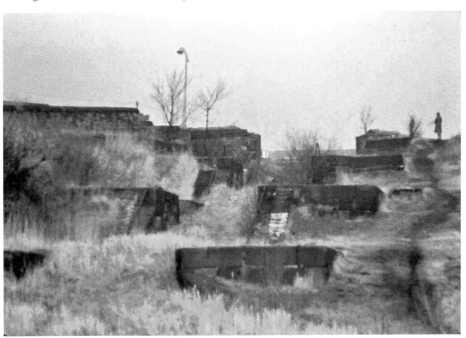

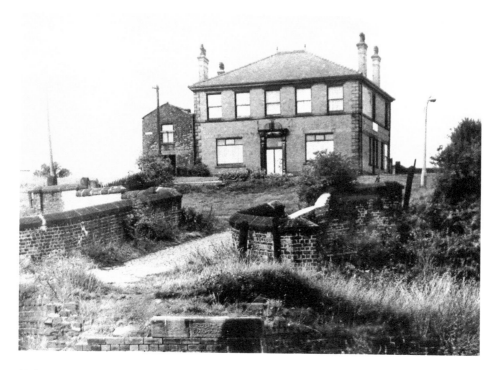

Nob Inn

A pub was a necessity alongside so many locks, and it was already open as the Boat House by 1825. It is named as the Nob Inn on the 1845 Ordnance Survey 6-inch map. In the upper picture, taken in the 1960s, it is clearly closed, but more recently it has become home to a luxury cattery. The road bridge in the foreground is Nob Bridge over the start of the Bolton arm, which is the direction we now take.

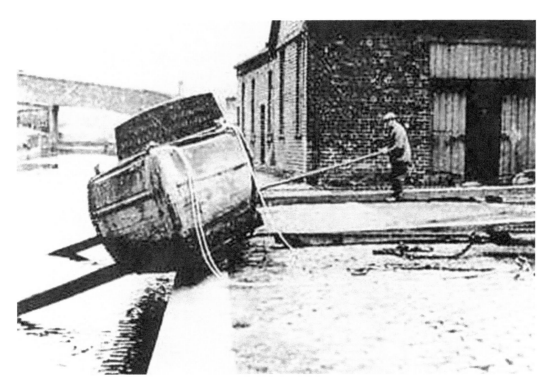

Nob End

At the start of the Bolton arm, the upper picture shows a maintenance boat being launched sideways outside the canal workshops; it may well be the boat that is still in the canal just opposite (*see page 49*). The lower picture shows the canal workshops, canal workers' cottages and the taller canal manager's house. Sadly the workshops were demolished in 2012, although the bricks were used to rebuild the Meccano bridge abutments and wing walls.

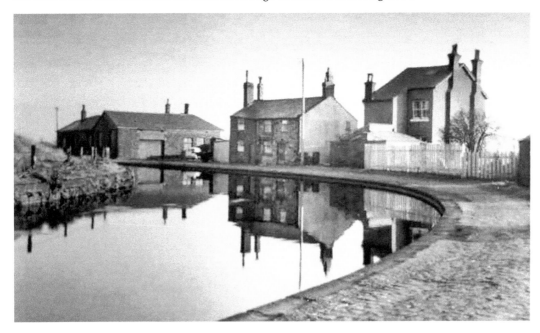

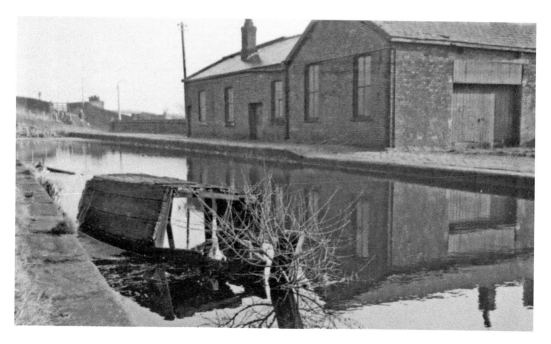

Nob End Workshops

The upper picture shows a maintenance boat in the canal in 1967; it is still there, minus its cabin. The lower picture, taken in 1980, shows the office inside the workshops. The building was often referred to as the 'Triangular Workshops' due to its odd shape. The Canal Society magazine has published extracts from the diaries written from 1893 to 1913 by father and son James and George Holdsworth, who were in turn canal foremen based at Nob End. (*Photographs courtesy of www.heritagephotoarchive.co.uk*)

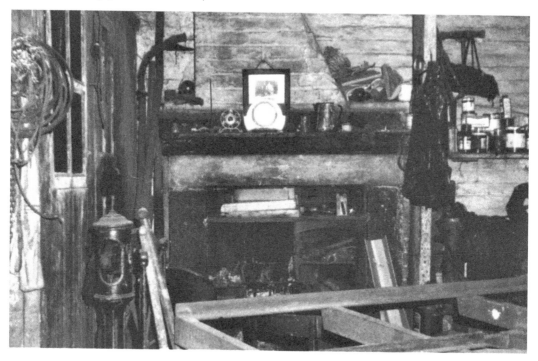

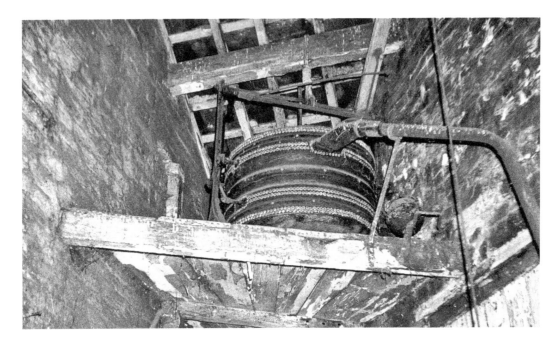

Nob End Workshops

The pictures show the bellows above the forge and anvil, taken in 1980. The workshops were at the junction of the three arms of the canal; well placed to serve the whole canal. James and George Holdsworth regularly walked and inspected the whole canal. The diaries also record repairs, ice-breaking, floods, droughts, The Great Trespass (*see page 72*), and sadly the drowning of George's wife in the canal in 1907 ('Drowned herself whilst temporarily insane'). (*Photographs courtesy of www.heritagephotoarchive.co.uk*)

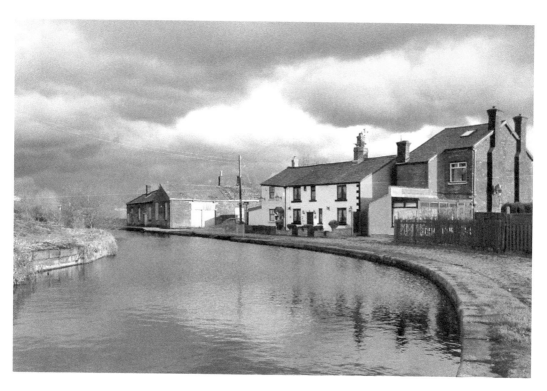

Nob End

Two more pictures of Nob End, with and without the workshops. This is a favourite spot for photography, even though the houses face north and their fronts are rarely in sunlight. The area is dominated by the tall Wellfield House, on the opposite bank of the canal.

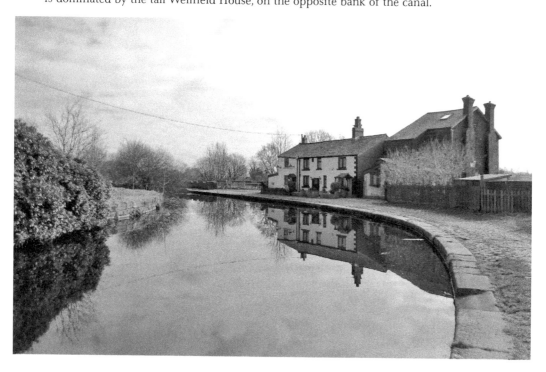

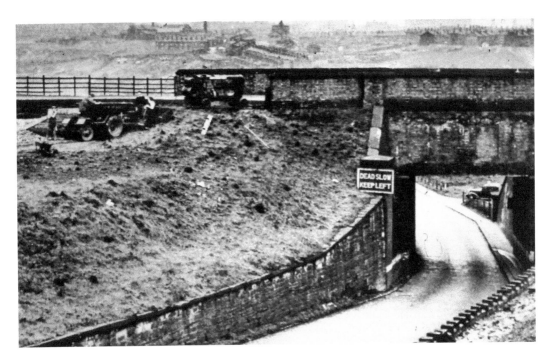

Farnworth Bridge Aqueduct (Hall Lane)

The canal is in water for ¾ mile, but stops abruptly where the aqueduct used to be. It was rebuilt in 1884/85, but the roadway was only 21 feet wide and was demolished in 1950; only a length of blue brick remains on the right-hand side. The Bolton arm had been largely disused from 1924 and two more aqueducts have since been demolished, which will make it difficult to restore the canal beyond this point.

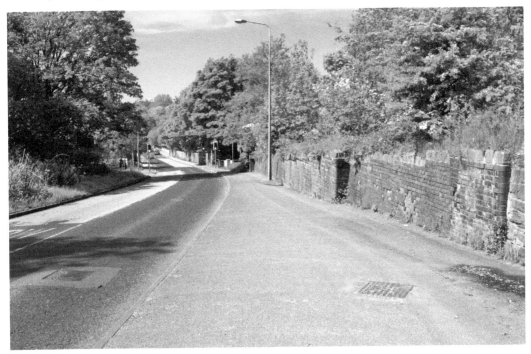

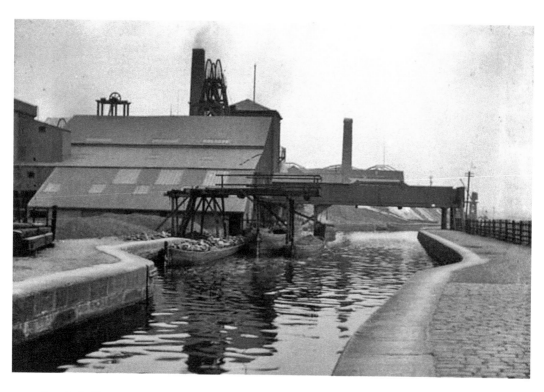

Fogg's Colliery

This colliery closed in 1912. Fogg's Aqueduct, seen in the foreground of the upper picture, was only 15 feet wide, and was demolished in 1967. The lower picture shows the infilled canal just beyond this spot today; only the coping stones are visible.

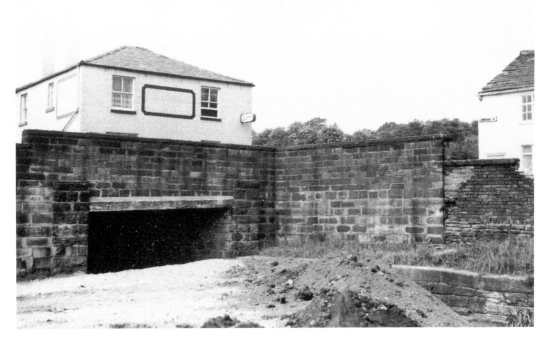

Smithy Bridge

This bridge in Darcy Lever was rebuilt in 1935, even though the Bolton arm of the canal was disused. It replaced the previous bridge, which was the lowest on the canal with a headroom of only 7 feet 3 inches. Two canalside pubs were nearby.

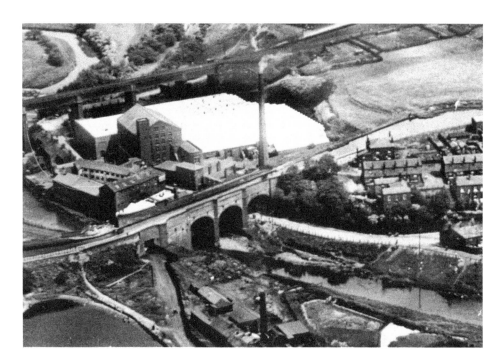

Damside Aqueduct

The massive Damside Aqueduct was 91 yards long, and had three arches over the river and main road, plus a smaller arch over a minor road. It was repaired in 1879–82 and again in 1901 (described in great detail in the Holdsworth diaries). Despite being described as unsafe it took three attempts to demolish it with explosives in 1965, and the lower picture shows that virtually nothing remains in the bed of the River Tonge.

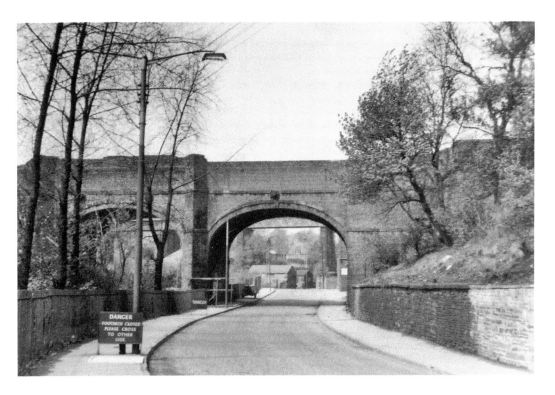

Damside Aqueduct

The aqueduct before demolition and today. The lattice girder Darcy Lever Viaduct of the former Bolton to Bury Railway line, seen beyond the aqueduct, still stands. The last visible length of canal structure today is just beyond the aqueduct, near the underfilled Bentley Bridge at the end of Darcy Street.

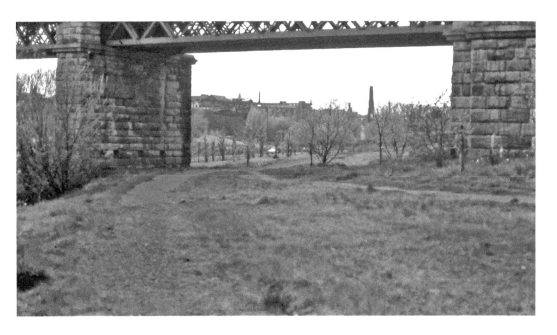

Burnden Viaduct

The disused viaduct of the Bolton to Bury Railway line still crosses the line of the canal. These photographs, taken in the 1980s and today, show the extent of tree growth. In the upper picture the chimney is probably that of the former Springfield paper mill.

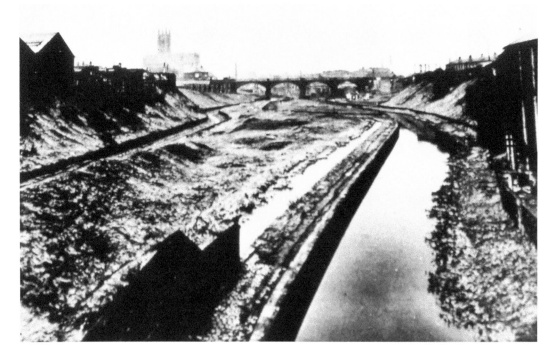

Bolton

The upper picture was taken from Bradford Street (later Haulgh) Bridge in 1947, and shows the final length of the canal approaching Bolton. The lower picture, taken some distance further back, shows St Peter's Way (A666), opened in 1973, completely covering the line of the canal. Springfield paper mill was formerly in the foreground of this picture. Bolton parish church can be seen in both pictures.

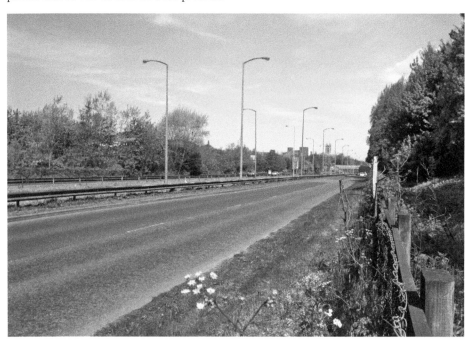

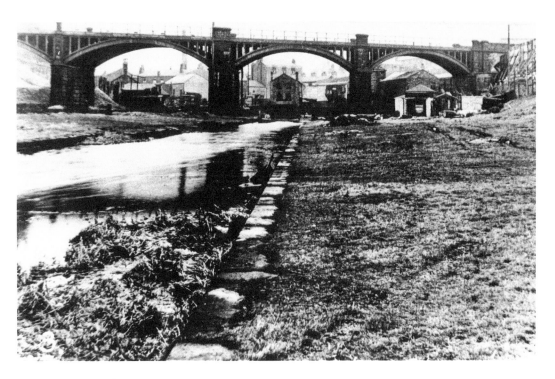

Bolton Terminus

The canal formerly ended at a warehouse just beyond the Bolton to Blackburn Railway viaduct, built in 1847. The southbound carriageway of the St Peter's Way (A666) now occupies the span that formerly allowed the canal to reach its terminus. The area is still known as Church Wharf as it lies immediately below the parish church. The warehouse remained in use for other purposes until the 1960s.

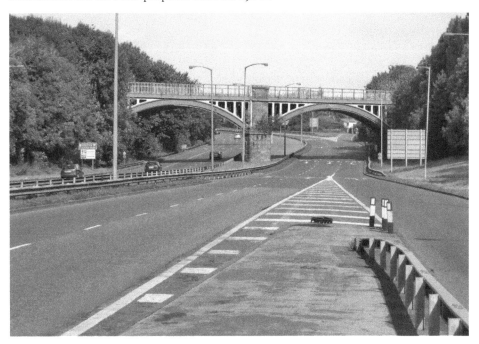

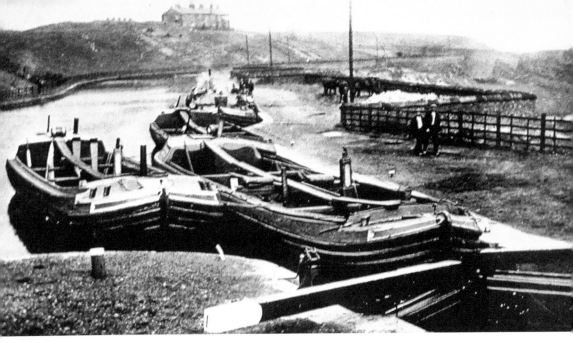

Nob End

Back at Nob End, the upper picture looking towards Bury shows boats at the top of Prestolee Locks. The first 200 yards of the canal had become extensively overgrown and a large working party cleared it of trees between Christmas and New Year 2010. A Meccano picnic area and monumental milestone were erected close to here in 2013 (*see page 95*).

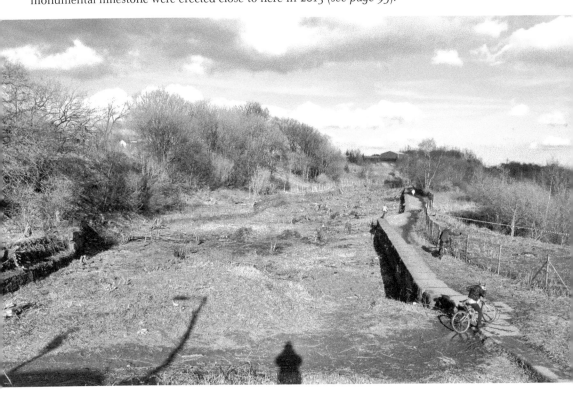

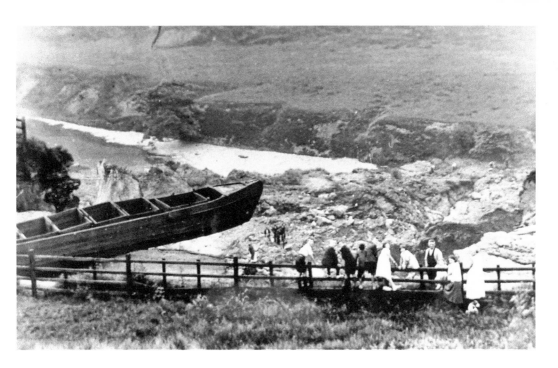

The Breach

The canal bank burst on 6 July 1936, draining the canal, blocking the River Irwell below, and flooding Creams paper mill (just upstream). The cause is very clear from looking at the lower picture; the rock strata dip down the slope, and no doubt a leak had lubricated the rock to cause the massive slippage.

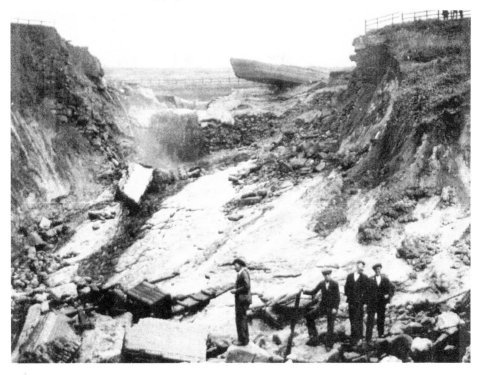

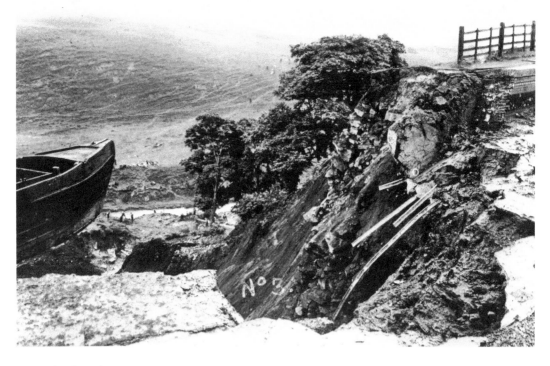

The Breach

The Holdsworth diaries show that this length of canal was a problem, and was often closed and drained for repair. For example, on 26 September 1911, 'At leak between Nob and Baily Bridges found very bad hole 3 feet by 2ft ... 9 feet deep .. was filled with concrete and clay on top.' As traffic on the canal had declined and been replaced by road transport, the breach was never repaired, and the Bury and Bolton arms were both severed.

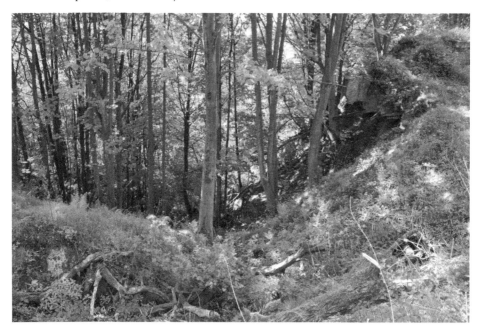

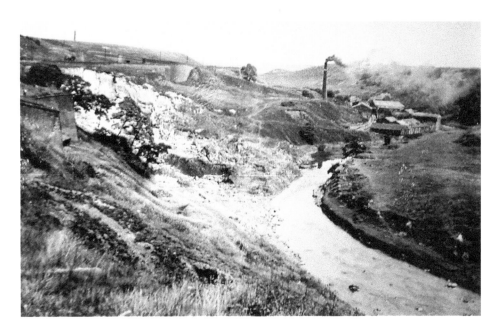

Creams Paper Mill

Creams was probably making paper from 1677, closing only in 2004. The upper picture shows how close it was to the breach. The lower picture was taken in the 1950s, and a new storage shed had been built on the line of the drained canal, to the left of which is Baily Bridge. From the top a short tramway called Jig Brew took coal down to the boiler house. Most of the mill is by the river, as papermaking requires a lot of water.

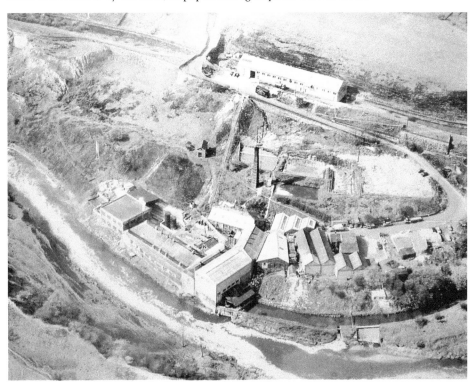

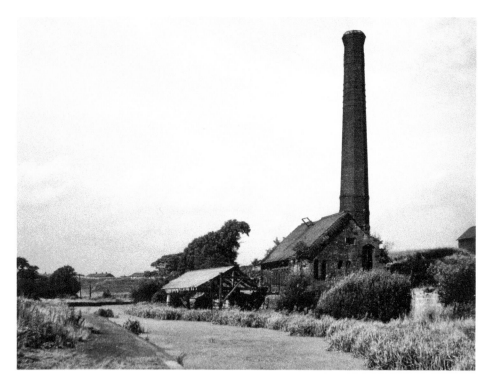

Ladyshore Colliery

Ladyshore was already operating in the 1830s, and it closed in 1949. There were shafts on both sides of the canal, connected by a tramway. The upper picture was taken in 1968 when many of the colliery buildings were still standing. The colliery offices and some adjacent buildings are now houses, and the scene looks very different; the lower picture is taken from Ladyshore Bridge, rebuilt in 1894. Nearby, several sunken boats can still be seen in the canal.

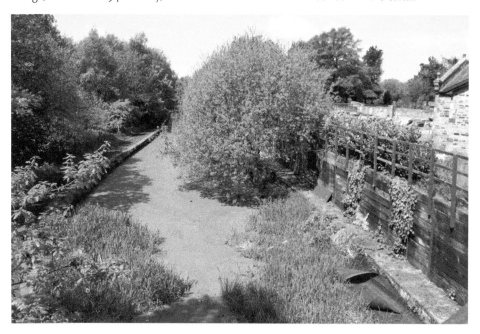

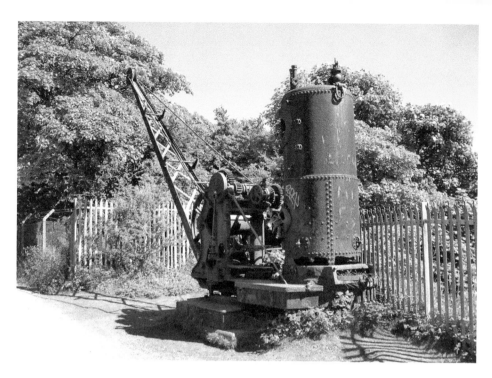

Steam Crane

The iconic steam crane at Mount Sion, used as the canal society's logo, was made in Leeds in around 1884. It was used to transfer coal from the canal to the former bleach works below. The mill now produces specialist pulps, and it owns the crane. The crane is a Listed structure, and is in need of some restoration, but the problems are extensive. At least the society has painted it in protective paint.

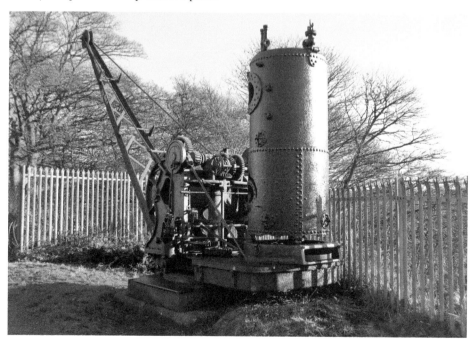

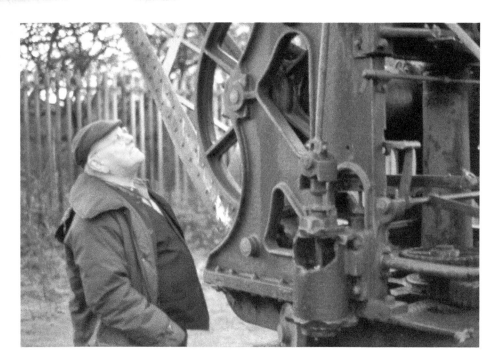

Fred Dibnah and the Steam Crane

Fred was honorary president of the canal society for several years until his death in 2004. The working parts of the crane are in reasonable condition, but the real problem is that the bottom of the vertical boiler has corroded so that you can see right through it. We had always hoped that Fred might repair it!

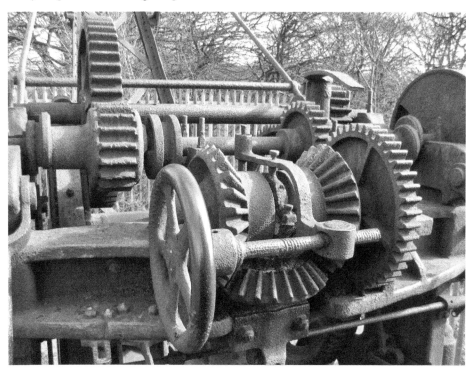

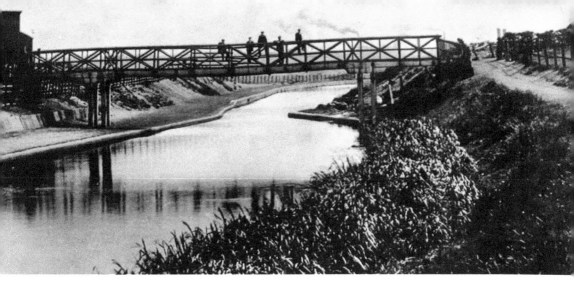

Scotson Fold Bridge

There have been several bridges on this site. This private timber footbridge was 8 yards further north of the later bridges; it was replaced by a wrought-iron bridge in 1905, and by the present steel bridge in 2008. The bridge plates installed by British Waterways some years ago are all wrong – this bridge is actually No. 72, as numbered by the LMS earlier in the twentieth century! It is now more often called School Street Bridge.

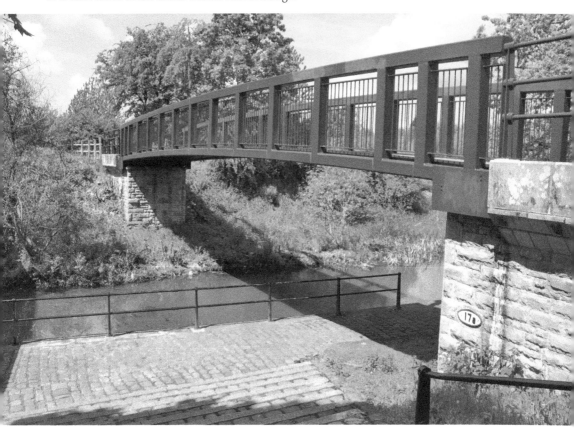

Water Street Bridge

Originally an arched bridge, it was replaced by a wrought-iron bridge in 1879. When the canal closed it was underfilled, and the present embankment was created in 1985. Plans exist to restore this bridge to full navigable standards. The ¾-mile length of canal leading into Radcliffe has recently been dredged and the towpath improved, using money from housing and retail developments.

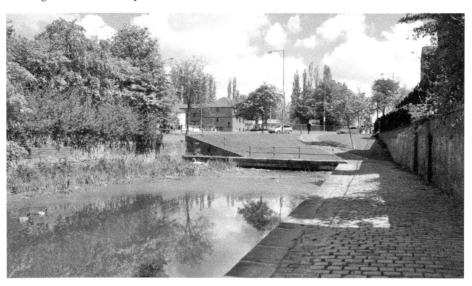

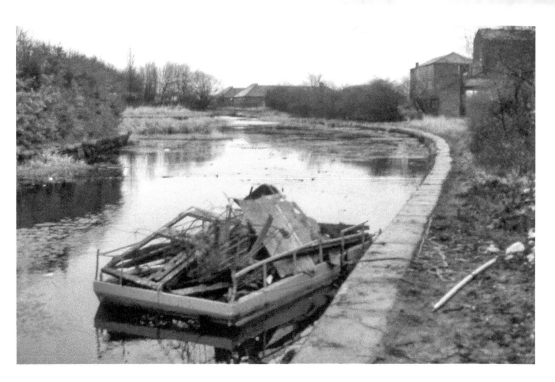

Radcliffe

The upper picture shows the basin in Radcliffe during the canal society's first working party in 1988; clearly Radcliffe did not love its canal! Since then, with help from local volunteers, the towpath has been much improved. The canal society ran a boat from here in the 1990s.

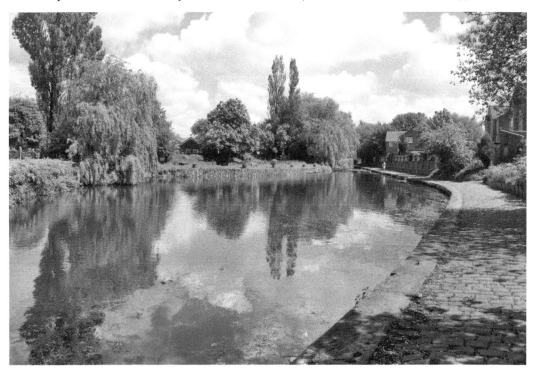

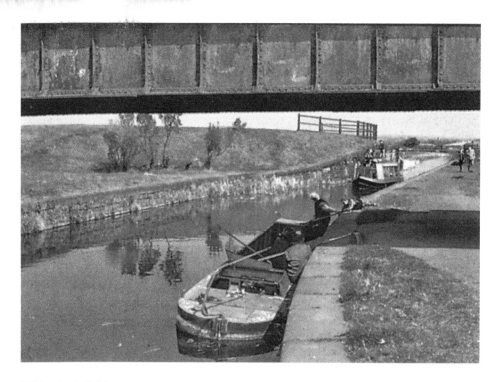

Whittaker's Bridge

There are three bridges close together here; the first and last were railway bridges, but this middle bridge was an occupation bridge built in the 1870s to replace one on the site of the first railway bridge. It now has an installation by the New York conceptual artist Lawrence Weiner, created in 2005 as part of the Irwell Sculpture Trail. It bears the words 'WATER MADE IT WET' in red paint.

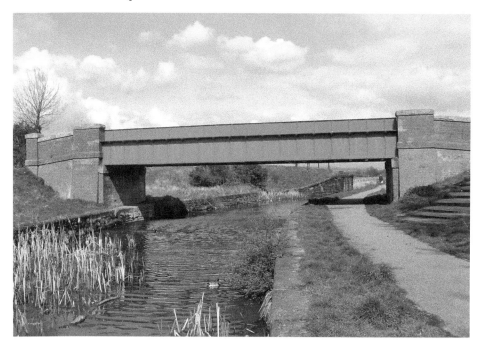

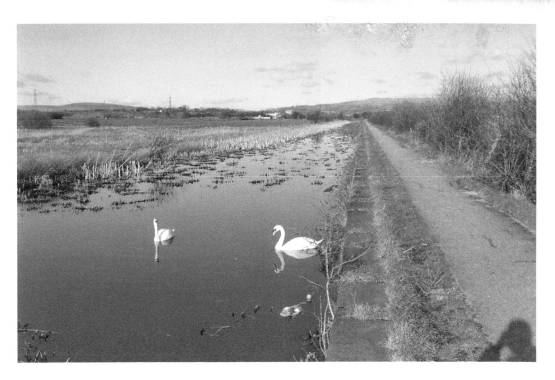

Towards Elton Reservoir

A long, straight length of canal, with a good surface laid by Bury Council, leads to Bank Top Bridge with tall, thin boundary stones on the approach. Originally an arched bridge, it was rebuilt in wood in 1876 and in cast iron in 1897. In 2013 it was lacking permanent parapets. From the bridge, a diversion to see Elton Reservoir can be made.

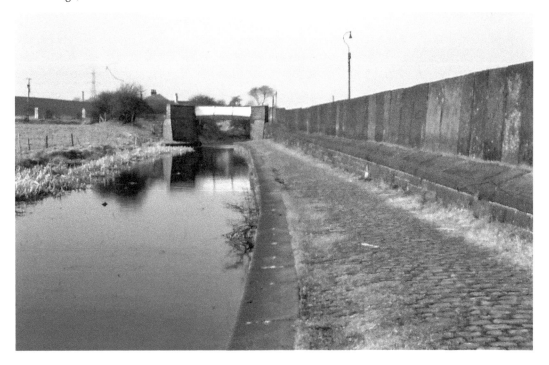

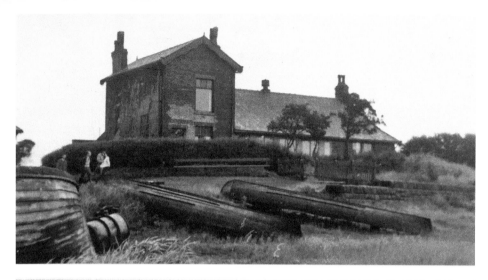

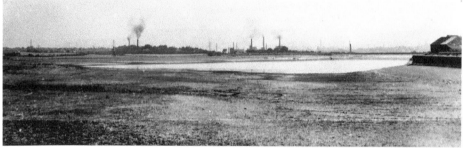

Elton Reservoir

Elton is the canal's feeder reservoir, built in 1805. The upper pictures show the club house for Elton Sailing Club and the reservoir with low water, a situation often recorded in the Holdsworth diaries. Elton became famous early in the twentieth century when the canal company erected a fence to stop people walking along the embankment; the fence was broken down and 'The Great Trespass' court case followed, again recorded in the Holdsworth diaries.

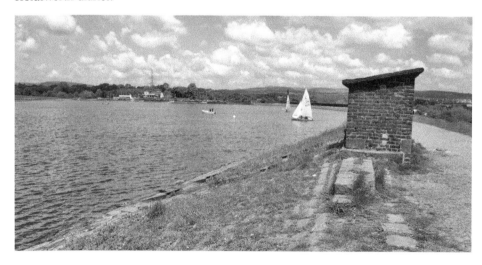

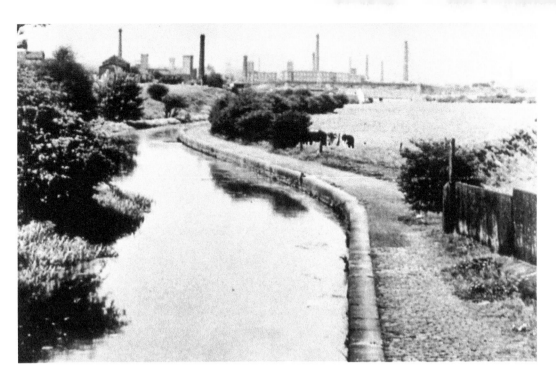

Towards Bury

Two pictures taken from Bank Top Bridge with the River Irwell to the right. The feeder from Elton Reservoir enters on the left, opposite a 1977 concrete overflow. The last visible milestone (11¾) is a few yards further along, and a little way beyond that the canal was infilled in 1977/78.

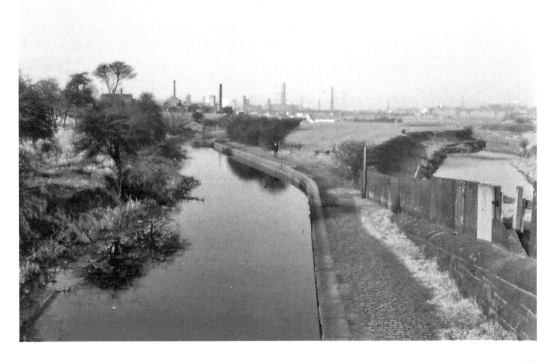

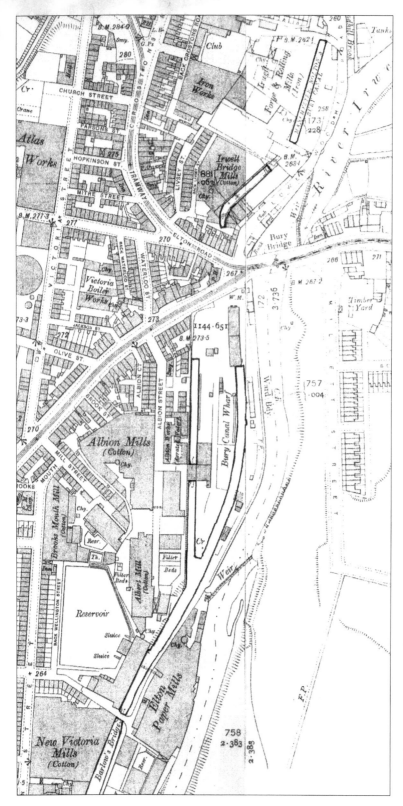

The Bury
Terminus on the
Ordnance Survey
25-Inch Map, 1908
The highlighted
canal passed New
Victoria Mills and
Elton paper mill
before splitting
into two arms.
The left arm
went under a
stone warehouse
while the right
arm went past
wharves to enter a
brick warehouse,
and straight into
a tunnel under
the junction of
Bolton Road and
Elton Road. The
canal emerges
twice before its
final end, serving
various mills.

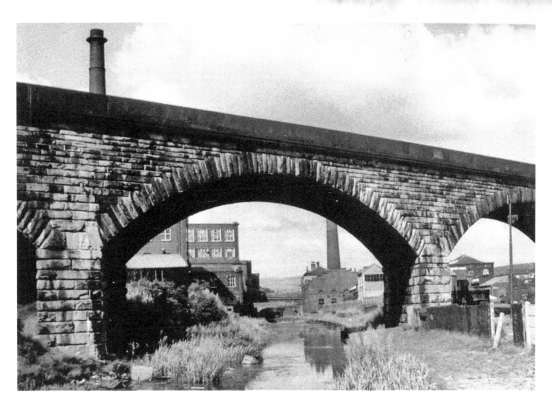

Daisyfield Viaduct

The viaduct carried the Bolton to Bury Railway line of 1845 over Wellington Street, the canal and the River Irwell. The upper picture was taken in 1968, showing New Victoria Mills and Elton paper mill through the arch. Since then the canal has been infilled, but its route is still clear. In 2013 there was a proposal to turn this length into a fire and rescue training centre.

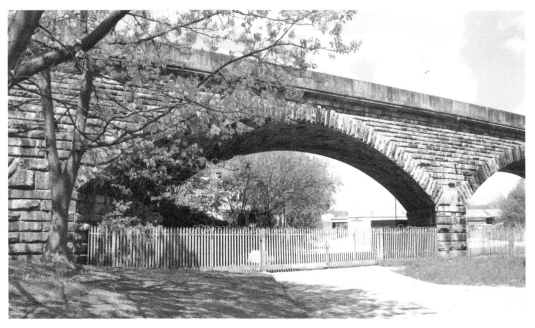

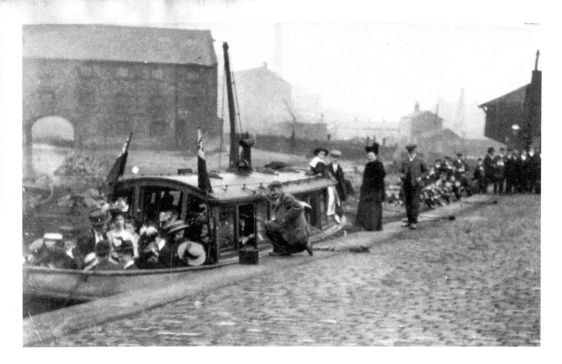

Bury Terminus

The upper picture, probably taken before the First World War, shows boats preparing for an outing on the canal – note the sex segregation! It was taken at the junction of the two arms, and both warehouses are visible. The lower picture shows the canal running through Elton paper mill, and Barlow's (later Crompton's) Bridge is visible beyond. The canal was used until 1966 to bring coal from Bolton Road to the mill.

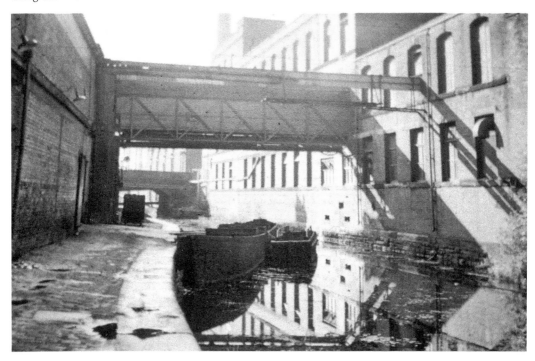

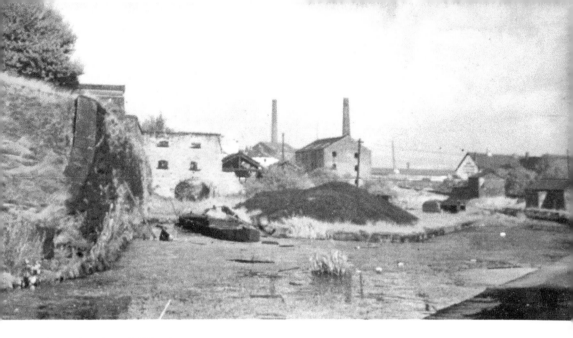

Bury Terminus & Warehouses

The upper picture shows both warehouses in the 1960s; the stone warehouse on the left has been partly demolished, and both were taken down in 1972. The lower picture shows the side wall of the stone warehouse, still visible in the long wall behind the industrial units.

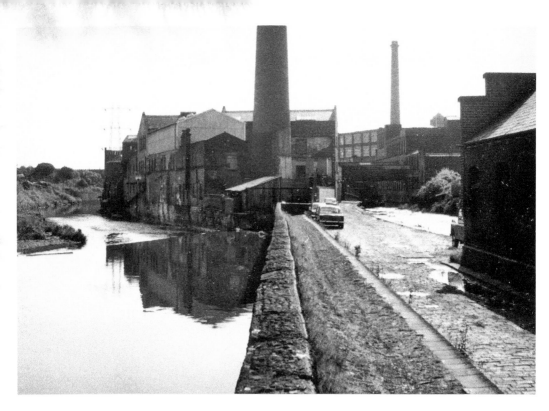

Elton Paper Mill

The upper picture, taken in 1968, shows the paper mill on its narrow site between the River Irwell and the canal, with the New Victoria Mills beyond. The lower picture shows almost the same view today. The paper mill has gone and the canal is infilled, but the weir in the river and the electricity pylon remain; New Victoria Mills are hidden by the tree.

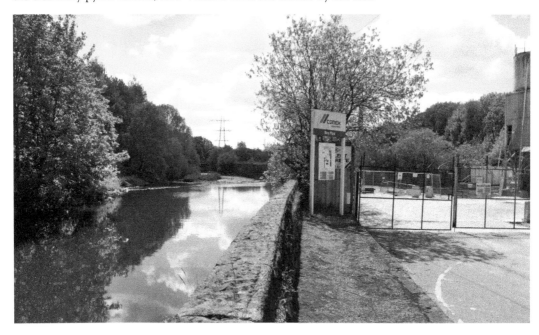

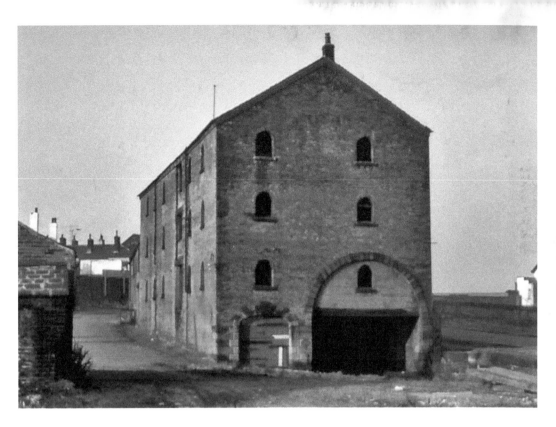

The Brick Warehouse

The right-hand arm of the canal went into the brick warehouse very close to Bolton Road; the canal continued under the road in a tunnel totalling 141 yards in length. The warehouse was demolished in 1972 and the canal filled in. Today only the river boundary wall survives, and the area is now an industrial estate and car park.

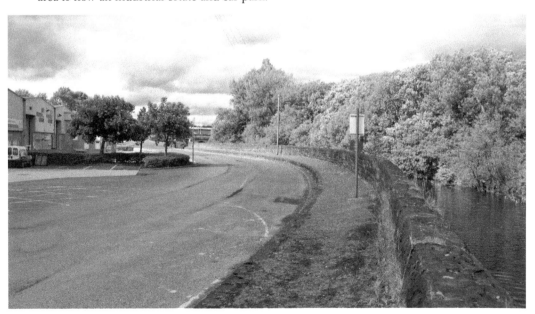

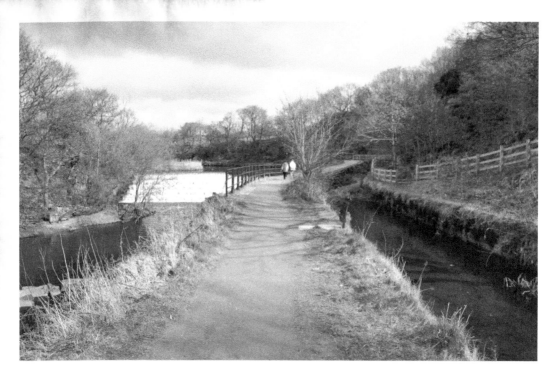

Canal Feeder

The feeder is best seen at Burrs Country Park, a mile above Bury. The upper picture shows the weir above Burrs; the canal feeder still feeds water to the canal and also used to take water to Burrs bleach works and Woodhill paper mill. The lower picture shows the aqueduct carrying the feeder across the River Irwell at Burrs.

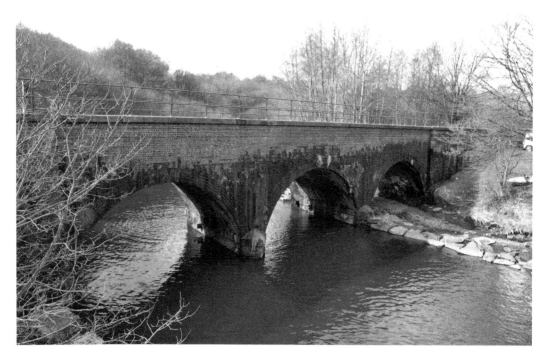

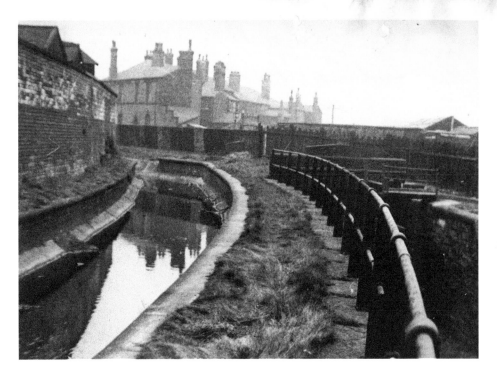

Canal Feeder

Two pictures taken in 1954. The upper picture shows the feeder next to the gas board railway tunnel entrance, south of Bolton Road. The lower picture shows the feeder between Fairy Street and Bolton Road (seen in the background); there is now a car sales showroom below the feeder to the left of this picture.

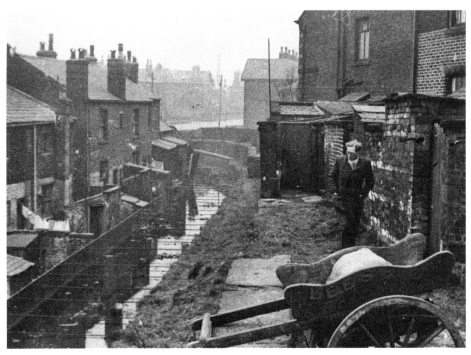

Locks

	No	Rise Ft	Ins
River Locks*	1/2	17	8
Ordsall Lane	3	10	9
Oldfield Road	4/5	23	10
Oldfield Road	6	7	6
Rhodes	7	10	9
Giants Seat Bottom	8	11	6
Giants Seat Top	9	10	6
Ringley Bottom	10	10	10
Ringley Top	11	9	9
Prestolee Bottom	12–14	35	0
Prestolee Top	15–17	29	2
Total Rise		177	3
Minimum length:		72	9
Minimum width:		14	8

* now new deep lock

Maximum size of boats: 68 feet by 14 feet 2 inches
Draught: 3 feet 6 inches, Headroom: 7 feet 7 inches

Milestones

The quarter milestones were installed soon after the canal was completed to help calculate charges for the movement of goods. There were probably sixty-one stones; twenty-nine are still in place, two are in store, one is inaccessible, one in the canal and one presumed buried. Originally most were placed on the offside, where the 1881/82 canal maps show them, but by 1890 the Ordnance Survey 25-inch maps show they had moved about 150 yards towards Salford, and most moved from the offside to the towpath side; the reason behind this move is unknown but may be a result of the lengthening of the canal caused by the railway deviations in Salford in the 1830s and 1890s. Only two now remain on the offside, both on the Bury arm (milestone 10¾ & milestone 11¼).

The milestones were surveyed by thet author in 2003; most were in good condition. Milestone 9 on the Bolton arm is out of the ground, and shows the original full size of the stones; it is 43 inches tall. They have a simple style of engraving – the letter 'M' with the distance from the river lock in miles. The M stands for either the distance from Manchester, or just for miles; the latter is more likely as the zero point is not in Manchester. It is interesting to analyse the stones by looking at their shape, size and lettering. Most are square-topped, but five have rounded tops and two are intermediate. Lettering and size show groups of stones probably made by the same mason. Nine milestones look very similar: M3½ to 4, M7¼, M7½ and M8 to 9 on the Bolton arm. All are about 20 inches wide and 10 inches front-to-back. Another obvious pair are the round-topped M11¼ and M11½ on the Bury arm; these are much smaller, being 14 inches wide and only 6 inches

front-to-back. Since 2003, the society has repaired the broken M3 at Agecroft Bridge, reinstalled M6¾ behind the Horseshoe pub in Ringley, and M8¼ above the former Creams paper mill in Little Lever. In 2013 Yolande Baxendale created a new monumental milestone 8 at the junction of the three arms of the canal near the Meccano bridge at Nob End (*see page 95*).

To see the milestones is quite easy, as most of the survivors are adjacent to each other. From Ringley to Nob End there are three stones (plus one at Prestolee Bridge which is in the canal); from Nob End to Hall Lane there are another three; and from Nob End to Elton there are thirteen. The other surviving group is from Agecroft to Clifton, where there are four stones. A new M¼ was carved during the Middlewood restoration. A selection can be seen on page 84.

Tram Roads

Many tram roads, twenty lines in all, with a total length of over 6½ miles, were connected to the MB&BC. Most brought coal from local pits to the canal, and other lines linked the canal to a bleach works, a brick and tile works, a paper mill and several quarries. In practical terms these lines were part of the canal's transport system, and are thus an important part of its history. Tram roads were an integral part of the transport system before the coming of the railways; many of these lines survived in use into the twentieth century. There were three different types of line: tubways (using 7cwt tubs straight from the mine), tram roads, and light railways. They were built to a variety of gauges, and were operated by men, horses, rope, chain or steam engines. All were privately owned.

The remains of several tram roads can still be seen. The best preserved is from Ringley to Outwood, pictured on page 33. Others can be seen at Agecroft, Clifton, Stopes (Little Lever), and Bealey's (Radcliffe). A full description can be found on the society's website.

Manchester Bolton & Bury Canal Milestones

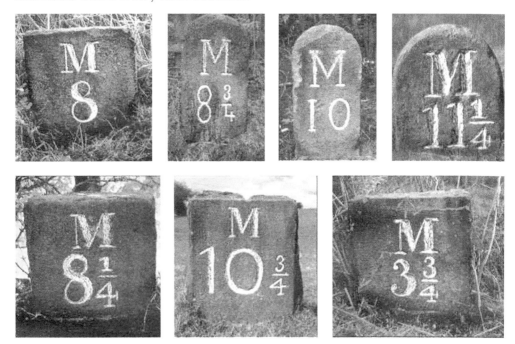

A walk on the

Manchester Bolton & Bury Canal

from Moses Gate Country Park

MB&BCS

- A detailed guide to walking the **Manchester Bolton & Bury Canal** from Salford to Bolton and Bury, via Agecroft, Clifton, Giant's Seat, Ringley, Nob End, Darcy Lever and Radcliffe
 - *including Fletcher's Canal*

- Over **50 photographs**
 - many of the canal in its heyday
 - Middlewood restoration
 - Meccano Bridge

- **14 maps**, including
 - canal company plans (1881-2)
 - early Ordnance Survey plans
 - specially drawn maps of the canal

- A brief history of the canal

- Detail of canal tramroads, milestones, bridges and locks

- A guide to the restored Middlewood length in Salford

MB&BCS

Towpath Guide
2

Coal, Canals and Cotton

The Fletcher family in and around Bolton

Robert Cornish

The Canal Society

The canal society works with the Canal & River Trust and the three local councils (Bolton, Bury & Salford) to promote, maintain and restore the canal. Regular meetings working with our partners have proved immensely useful over the years. The society publishes a quarterly magazine, booklets, publicity leaflets, and a walking guide. The invaluable *Towpath Guide 2* was updated in 2013. The society's other activities include regular working parties, open lecture meetings, and a sales stand.

Restoring the Manchester Bolton & Bury Canal

Manchester Bolton & Bury Canal Society

MB&BCS

Bolton Council

Bury COUNCIL

Restoring the canal
through Bolton, Bury and Salford

No 98 May 2013
'Meccano' Bridge Opening
Souvenir Edition

Restoration 1: Middlewood Locks

The restoration of the start of the canal in Salford was announced in 2002 and launched in 2005, but work on site did not begin until 2007 and the first length of the canal was reopened on 19 September 2008. The delays were due to difficulties in getting funding and planning permission, and complex negotiations with existing landowners. There were several technical problems too. The Salford Inner Relief Road had been built over Lock 2 in 2001/02, largely destroying it, but a 1-metre-thick concrete slab had been installed so that the canal could be tunnelled underneath the road at a later date.

It was first intended that there should be two replacement locks for the original staircase pair of Locks 1 & 2, separated from each other and Lock 3 by two large pounds to provide extra water storage. During the design process, it was decided to build one new deep lock instead, though the two pounds remained in the design. The restoration rejoined the original line of the canal at Lock 3, which was found to be in excellent condition. Ordsall Lane Bridge, which crosses the canal immediately below Lock 3, was rebuilt. The restoration continued to just beyond the original site of Lock 4; this had been moved in the 1830s when the Manchester to Bolton Railway line was built, and for some time it had been converted into 'Salford No. 1 Tunnel' (*see pages 13–14*). Due to considerable industrial pollution, the restored canal between Lock 3 and old Lock 4 was rebuilt in concrete inside the original line of the canal. This length of the canal had no water supply, and large pumps were installed to back pump water from the new tunnel to above Lock 3 (and eventually to above Lock 6). These pipes are clearly visible below Lock 3. (*Photograph courtesy of Webb Aviation*)

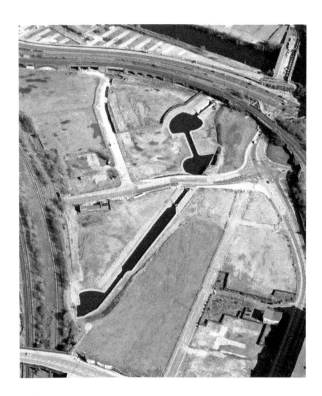

Lock 3 to Old Lock 4
The upper picture shows the excavated Lock 3 in September 2007; the two British Waterways staff are standing where the top lock gates will be installed. The lower picture shows the new winding hole, the narrows of old Lock 4 (later Tunnel No. 1), and the canal leading to Lock 3. The Beetham Tower stands high in the distance.

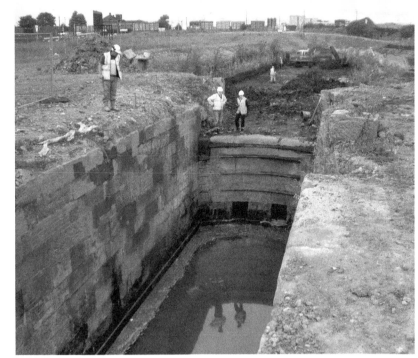

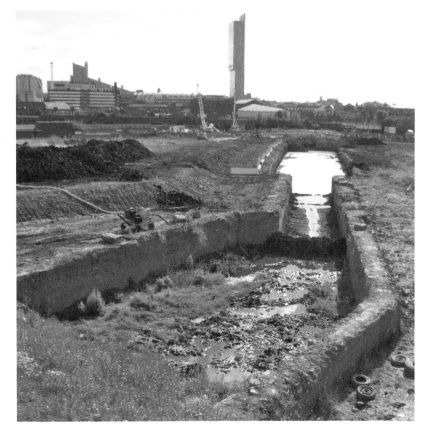

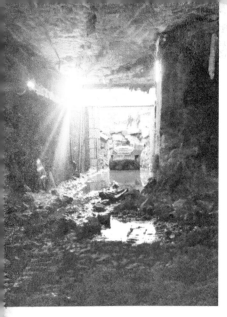
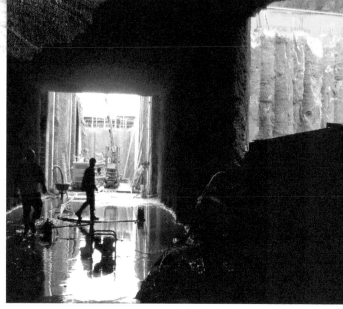

The Tunnel & Deep Lock

The upper pictures, taken in January 2008, show the new tunnel excavated where Locks 1 and 2 once stood. The photograph at the top left is looking towards the river into Lock 1, and the imagage at the top right is looking into the almost completed new deep lock; the opening on the right will enable boaters to disembark and operate the lock. Below left are the newly-installed bottom lock gates of the deep lock in August 2008. Below right is the first boat entering the tunnel on 19 September 2008.

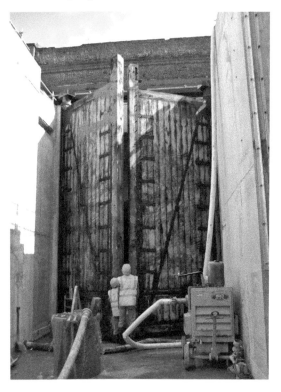
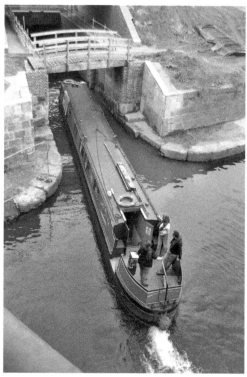

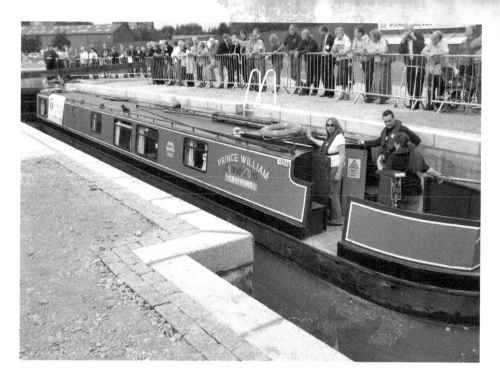

Middlewood Opening Day

Narrowboat Prince William was the first boat to ascend the deep lock, carrying the mayors of Salford, Bolton and Bury. Eventually three boats ascended, though Lock 3 was still inaccessible due to cables blocking the way. Boats can be seen in and above Lock 3 in 2009 on pages 12 and 14.

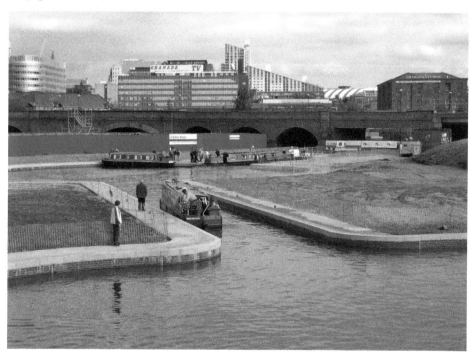

Restoration 2: Nob End Meccano Bridge

The old wooden 'horse bridge' that spanned the top lock at Nob End had gone by 1970. In 2010 Bolton Council found proceeds from a housing development to fund an artwork in Little Lever, and commissioned local public artist Liam Curtin to design it. After much public consultation and several different designs in two locations, he decided to build a replacement bridge at Nob End using Meccano scaled up ten times. The colours were chosen to match Meccano of the 1950s. Due to the unique nature of the design the engineering details took a long time to be worked out, but work eventually began in October 2012. The canal society took on the role of principal contractor, and put in over well over 3,000 man (and woman!) hours of volunteer labour to rebuild the abutments, wing walls, approaches and the bridge itself. Volunteers came both from the canal society and from local residents. The Meccano pieces and the nuts and bolts were all made in Bolton, though the decking is German. The Meccano pieces are 8mm galvanised steel, and the nuts and bolts weigh 1.2 kg each. This unique bridge has attracted much attention from both the general public and from Meccano enthusiasts worldwide. The photographs on the next six pages show the work from start to finish.

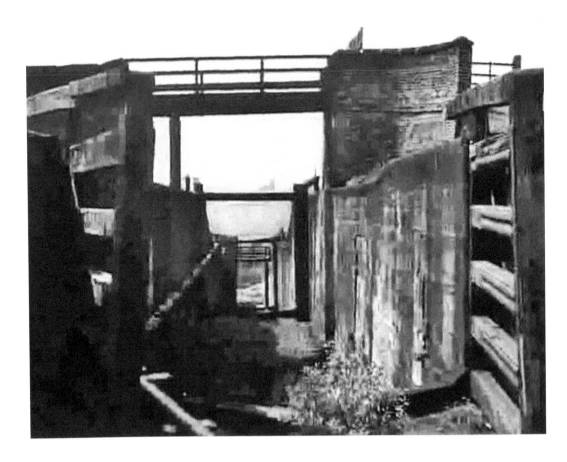

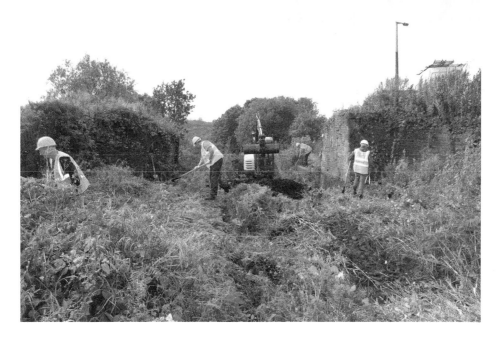

October, 2012

The site was heavily overgrown when work started; the first job was to clear the site. The north abutment (on the right) was almost complete, lacking only a few stones and the wing walls. The south abutment was in very poor condition, and two of its three walls had to be rebuilt from ground level. The bridge does not sit on the walls but on massive concrete plinths set behind. The bricks came from the former canal workshops (*see pages 48–51*).

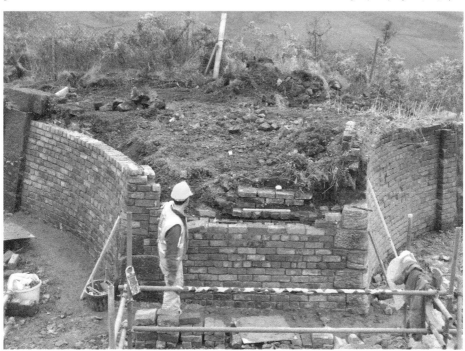

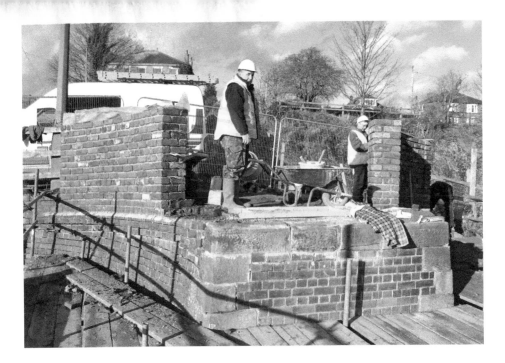

November, 2012

The upper picture shows the north abutment with the concrete plinth and wing walls ready for the bridge to be built. The lower picture shows the first trial erection. Liam is holding a 'toy' Meccano version of a bridge section – the scaled-up bridge is 10 times bigger and 1,000 times heavier! On the right is canal society working party organiser and principal subcontractor for the bridge Steve Dent.

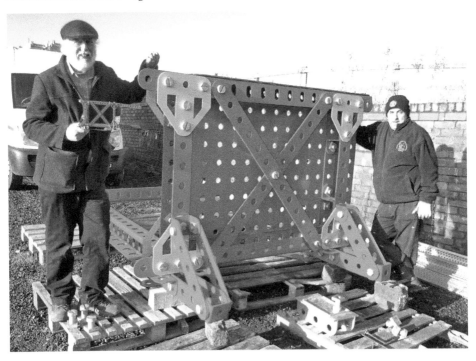

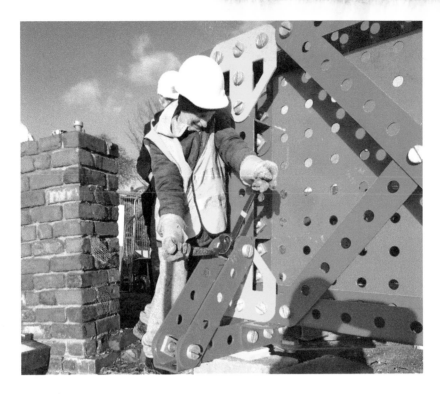

December, 2012

The nuts and bolts were tightened by hand, and members of the bridge building team are ready to remove the temporary supports. The heaviest elements were the red plates, which weighed 80 kg each and had to be moved by four people; every other part could be carried by one person. In total, the bridge weighs over 5½ tons and has over 720 nuts and bolts.

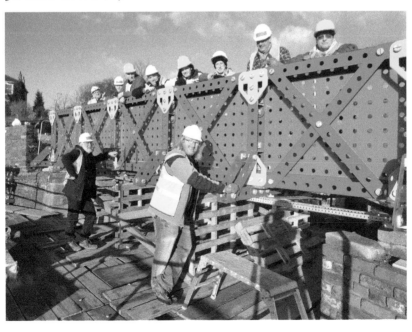

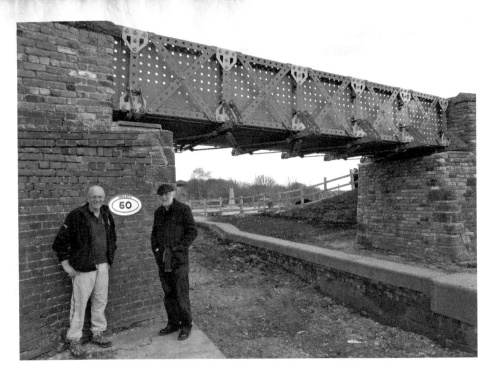

March, 2013

Paul Hindle and Liam Curtin are seen next to the new bridge plate (which has the correct number 50). Below, some of the lock-side setts are being reinstated by canal society volunteers. In both pictures the coping stones have been installed on the wing walls, but the brickwork has still to be pointed (using traditional lime mortar, which is best not done in winter).

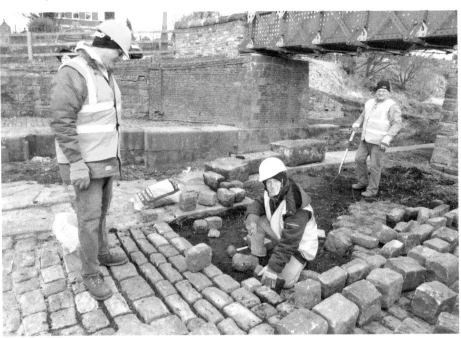

94

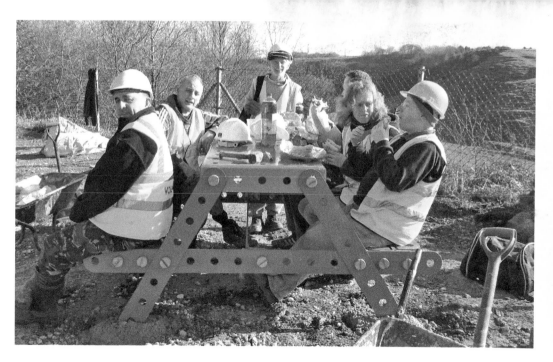

April, 2013

Next to the bridge, the canal society has installed a new picnic area with two Meccano picnic tables; the holes on top are perfect for holding hard-boiled eggs! In between the tables is Yolande Baxendale's new monumental milestone 8, with its three fins indicating the three arms of the canal that meet here; it is very close to the original milestone 8.

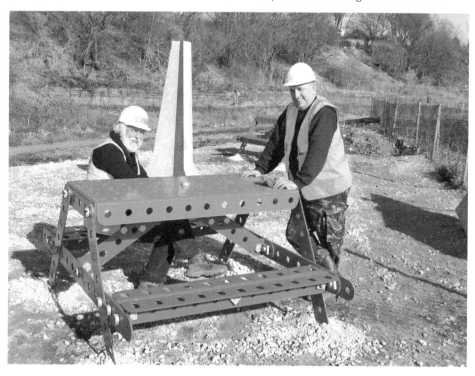

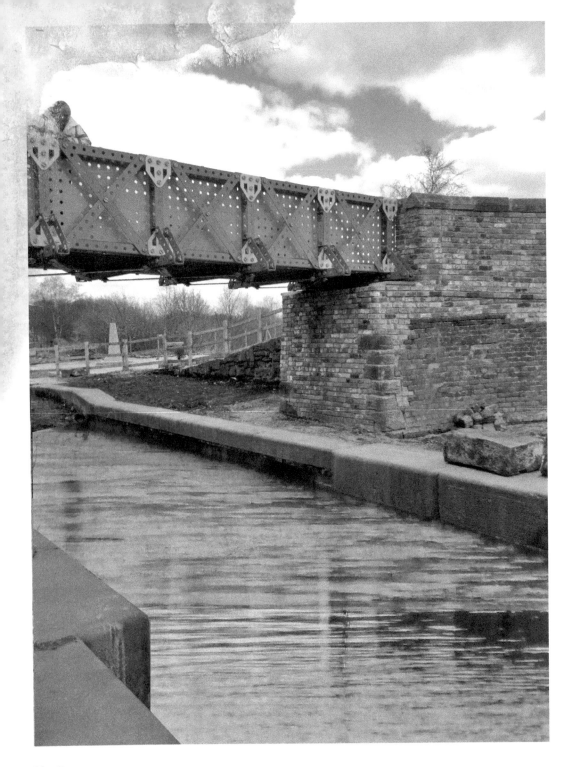

The Future
This shows what the Meccano bridge may look like when real (rather than digital) water once again fills the lock.